IMAGES
of America

HISTORIC RANCHES OF NORTHEASTERN NEW MEXICO

THE HISTORIC RANCHES OF NORTHEASTERN NEW MEXICO

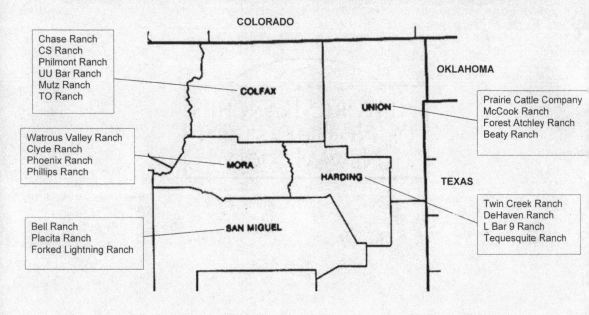

COLORADO

OKLAHOMA

Chase Ranch
CS Ranch
Philmont Ranch
UU Bar Ranch
Mutz Ranch
TO Ranch

COLFAX

UNION

Prairie Cattle Company
McCook Ranch
Forest Atchley Ranch
Beaty Ranch

Watrous Valley Ranch
Clyde Ranch
Phoenix Ranch
Phillips Ranch

MORA

HARDING

TEXAS

Twin Creek Ranch
DeHaven Ranch
L Bar 9 Ranch
Tequesquite Ranch

Bell Ranch
Placita Ranch
Forked Lightning Ranch

SAN MIGUEL

Five counties make up the northeastern corner of the state of New Mexico. Many of the most significant historic ranches in the state are located in this area of vast rangelands and mountain pastures. Featured in this book are historic ranches in Colfax, Harding, Mora, Union, and San Miguel Counties. (Author's collection.)

ON THE COVER: The front cover photograph was taken at Chase Ranch headquarters in Colfax County, New Mexico, on May 1, 1921. Pictured are, from left to right, cowboys Shorty Murray, Bob Dunn, Willie Dunn, and Walter Dunn and ranch owner George Mason Chase and his wife, Nettie. Chase Ranch cowboy Tommy Rupert is pictured on the back cover. (New Mexico State University Library, Archives and Special Collections.)

IMAGES
of America

HISTORIC RANCHES OF NORTHEASTERN NEW MEXICO

Baldwin G. Burr

ARCADIA
PUBLISHING

Published by Arcadia Publishing
Charleston, South Carolina

Library of Congress Control Number: 2015959963

For all general information, please contact Arcadia Publishing:
Telephone 843-853-2070
Fax 843-853-0044
E-mail sales@arcadiapublishing.com
For customer service and orders:
Toll-Free 1-888-313-2665

Visit us on the Internet at www.arcadiapublishing.com

*This book is dedicated to devoted editor, historian,
and friend Dr. Carleen Crisp Lazzell (1940–2015),
who was born and raised in Union County.*

CONTENTS

Acknowledgments 6

Introduction 7

1. The Historic Ranches of Colfax County 9

2. The Historic Ranches of Harding County 51

3. "I See by Your Outfit" 67

4. The Historic Ranches of Mora County 77

5. The Historic Ranches of Union County 85

6. The Historic Ranches of San Miguel County 95

7. Rodeos and Other Amusements 111

ACKNOWLEDGMENTS

Many people generously offered interviews, references, photographs, reviews, and encouragement as I was writing this book. The real reward for me in this effort was the privilege of meeting so many wonderful people, not only in the northeast corner of New Mexico but also throughout the entire state.

I want to thank the following individuals: Victoria Baker at the Herzstein Memorial Museum in Clayton; Kathy McQueary and Roger Sanchez at the Raton Museum in Raton; Gene Lamm at the Old Mill Museum in Cimarron; David Werhane at the Philmont Museum and Seton Memorial Library at Philmont Scout Ranch; Sharon Snyder at the Los Alamos Historical Museum; Leah Tookey, Toni Laumbach, and Dawn Santiago at the New Mexico Farm and Ranch Heritage Museum; and Cynthia Shetter, Andrea Chavez, and Hillary Madrid at the Los Lunas Museum of Heritage and Arts. I would especially like to thank Elizabeth Villa at New Mexico State University Library, Archives and Special Collections, for extraordinary technical services graciously rendered.

Bill Hill and Michael Jaramillo from Belen, New Mexico, Dorothy Valdez from Wagon Mound, New Mexico, Brian and Nicole King from Watrous, New Mexico, Suzanne Smith from Socorro, New Mexico, Gordon Hall from Alamogordo, New Mexico, and Tom Mitchell from Albert, New Mexico, graciously provided images from their private collections.

The following patiently allowed me to interview them, and provided information and guidance that enhanced the book from beginning to end. I want to thank Gene Atchley, Jodie Clavel, Joe Clavel, Bud Edmondson, George Hobbes, Rod Judy, Brian and Nicole King, Alfredo Laumbach, George Lovato, Richard Melzer, Chuck Pacheco, Paul Pharies, and Cynthia Shetter for their valuable insights.

Many people also thoughtfully reviewed draft chapters of the book and provided many helpful comments. I am grateful to Stephanie Brock, Joe Clavel, Gene Lamm, Tom Mitchell, Paul Pharies, David Werhane, Bonnie Wood, and Steve Zimmer. The last stage of every project is affixing blame, and because of the thoughtful work by these reviewers, the blame for any remaining errors is all mine.

I would also like to thank my title manager at Arcadia Publishing, Stacia Bannerman. She was enthusiastic about this project from the beginning and offered encouragement and support throughout.

Finally, I want to thank my wife, Laura, the lovely Mrs. Burr, for keeping the home ranch fires burning while I was roaming around "the Big Empty" of northeastern New Mexico.

INTRODUCTION

The northeastern corner of the state of New Mexico has been referred to as "the Big Empty," but that is deceiving. The landscape is far more varied than that, encompassing high mountain meadows, vast treeless grasslands, and spectacular canyons. The New Mexico counties of Colfax, Harding, Mora, San Miguel, and Union include more than 3,000,000 acres of grazing land that has traditionally been one of the finest cattle-raising regions in the United States. Many of these historic ranches, ranging in size from 10,000 acres to well over 500,000 acres, are still in existence today, some operated by descendants of the families that founded them.

In 1598, the Spanish explorer Juan de Oñate brought 7,000 head of cattle to New Mexico. Many of the cattle brought by the Spaniards became wild, and these longhorns became the foundation for great feral herds that roamed as far east as Texas.

In 1841, Charles Beaubien and Guadalupe Miranda received a land grant from Mexican territorial governor Manuel Armijo that consisted of almost two million acres of land in northeastern New Mexico and southern Colorado. In 1842, Lucien Maxwell, who had been a hunter and trader throughout the West, married Charles Beaubien's daughter Luz. By 1858, Maxwell had acquired through inheritance and purchase the Maxwell Land Grant and established his headquarters on the Cimarron River. Maxwell sold land to several others, such as Manly Mortimer Chase, John Dawson, and Frank and Charles Springer, who developed large ranching operations in what was to become Colfax County.

The first large herds of Texas cattle were brought into the northeastern part of New Mexico by Charles Goodnight and Oliver Loving in 1866, over the Goodnight-Loving Trail that ran from southwest Texas to Colorado. These were feral longhorn cattle that had accumulated during the Civil War when a Union blockade of the Mississippi River eliminated the market and made the animals nearly worthless. The Goodnight-Loving Trail entered New Mexico in the Pecos Valley, came north to Fort Sumner, and then branched three ways. The first branch went past Fort Union and Springer, and then over Raton Pass in Colfax County, New Mexico, into Colorado. The second branch went through Mosquero, Gladstone, Capulin, and Trinchera Pass in Harding and Union Counties. The third branch went to Tucumcari and Clayton, and crossed the Dry Cimarron River near Kenton, Oklahoma. The first two branches terminated at Pueblo, Colorado. The third branch extended all the way north to Wyoming. In 1867, some 37,400 head of Texas longhorn cattle were driven north on the Goodnight-Loving Trail.

By 1870, longhorn cattle were being crossbred with shorthorn cattle, but these cattle produced late-maturing calves and needed good pastures to thrive. After the advent of barbed wire, around 1880, ranchers began to import purebred Hereford bulls. Enclosed pastures meant that selective breeding could be practiced. The resulting hybrid cattle outweighed longhorns by an average of 300 pounds and could survive on sparse grasslands. The first Hereford bulls to reach northeast New Mexico were shipped to Las Vegas, New Mexico, in 1884.

As the cattle business boomed in the 1880s, many foreign investors formed cattle syndicates. Among the largest of these were the Maxwell Land and Cattle Company in Colfax County and the Prairie Cattle Company in Union and Harding Counties. The Prairie Cattle Company, with three separate divisions, extended from the Arkansas River on the north to the Dry Cimarron and Canadian Rivers to the south. The three divisions of the ranch totaled more than five million acres in New Mexico, Colorado, Texas, and Oklahoma; and the Prairie Cattle Company herds numbered over 140,000 cattle.

The historic ranches of northeastern New Mexico were owned by investor syndicates or by individual ranchmen, but the work of raising cattle and getting them to market was done by cowboys. Some said the difference between a rancher and a cowboy was his relationship to a banker. If he knew a banker's name, he was a rancher. If he did not know the name of a bank, he was a cowboy.

In the early days of open-range ranching, cowboys might go six months at a time without seeing anyone except fellow cowboys in their outfit or the camp cook. The cowboy owned his clothes, bedroll, and saddle but did not own his horses. Each cowboy would have a string of 10 to 12 horses that were valued for their individual skills. One might be a good roping horse, another a good night horse, and still another might be a good swimmer.

The home base for cowboys on the range was the chuck wagon. Charles Goodnight is thought to be the first to hang a large box on the back of a wagon, with a cover that folded down to form a large table. The box was divided into several different storage drawers and bins to hold the cooking ingredients. The wagon was also used to transport the cowboys' bedrolls and other personal belongings. On cattle drives, the chuck wagon would drive ahead of the herd to a location where the herd would stop for the night. On arrival, the cook would unhitch the team pulling the chuck wagon and then dig a fire pit, located so that the sparks would not blow over the camp and the cowboys. The tongue of the wagon was always facing the wind so that the wagon and chuck box would protect the fire. Bedrolls would be thrown from the wagon, and a pot rack would be set up over the fire pit. A fire would be built, and when it had burned down to coals, cast-iron Dutch ovens would be set in the coals and more coals were shoveled on top of the lids. Several ovens would be used for baking biscuits and cooking meat and potatoes. Beans and chili might be substituted for beef.

The ranch families who founded and operated the historic ranches of northeastern New Mexico were courageous, resourceful, and determined to succeed in an environment that was often discouraging and dangerous. They succeeded in spite of droughts, severe winters, fluctuating cattle markets, and just plain bad luck. They fought hard to maintain a sustainable lifestyle on cattle ranches both large and small. The measure of their success can be seen in the fourth and fifth generations operating those ranches today.

One

THE HISTORIC RANCHES OF COLFAX COUNTY

In 1841, the Mexican government granted land in northeastern New Mexico to Charles Beaubien and Guadalupe Miranda totaling almost two million acres. The landscape of the Beaubien-Miranda Land Grant ranged from sweeping grassland to high mountain peaks. Mountain man and trader Lucien Bonaparte Maxwell married Charles Beaubien's daughter Luz and began raising cattle and sheep on the grant land. He eventually acquired the grant through inheritance and purchase and renamed it the Maxwell Land Grant. In 1857, he established his headquarters on the Cimarron River where he built a large hacienda, mercantile store, and a gristmill.

In the 1860s, Lucien Maxwell sold land to Manly Mortimer Chase, who established the Chase Ranch in Ponil Canyon. Chase later joined with John W. Dawson to form the Chase and Dawson Cattle Company in 1873 and the Cimarron Cattle Company in 1881.

Lucien Maxwell sold the Maxwell Land Grant to a group of Coloradan and British investors. He had allowed individuals to homestead on the grant, raising cattle and engaging in mining activities, but the new owners insisted that the squatters either pay for the land they occupied or leave. The resulting conflict between the settlers and the land grant company was called the Colfax County War. The issue went to the US Supreme Court, which decided in favor of the grant owners in 1887 and set the size of the grant at 1,714,765 acres.

Frank Springer, who was legal counsel for the Maxwell Land Grant Company, along with his brother Charles, bought grant land and established the CS Cattle Company. The ranch is still operated by Springer descendants. Oklahoma oilman Waite Phillips began purchasing ranches located on the grant land in the 1920s, and he eventually owned nearly 300,000 acres, which he named Philmont Ranch. Phillips later donated almost 130,000 acres of his ranch to the Boy Scouts of America, thus establishing Philmont Scout Ranch, which, in 2014, saw the millionth Scout hike the ranch trails. Waite Phillips's UU Bar Ranch was purchased by Robert Funk in 2006.

Herman Mutz established a ranch in the Moreno Valley, and Mutz family members are still ranching in the area today. Antime Joseph Meloche, a native of Quebec, Canada, founded the TO Ranch in Colfax County. The TO Ranch is still in operation and has been owned by John C. Malone since 1999.

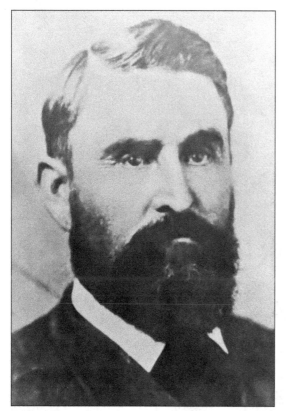

Charles Goodnight (1836–1929) became a cowboy in 1856 in Texas. In 1866, he and his partner Oliver Loving began rounding up feral cattle that had strayed throughout Texas during the four years of the war. Goodnight and Loving trailed their first herd north and pastured the cattle near Capulin Mountain in northeastern New Mexico. (New Mexico State University Library, Archives and Special Collections.)

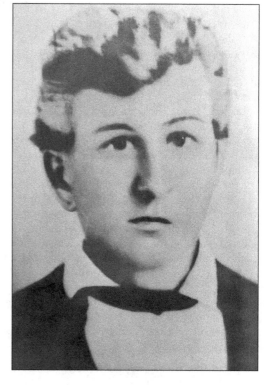

Oliver Loving (1812–1867) was Charles Goodnight's partner in herding cattle north from Texas into New Mexico on what became known as the 2,000-mile-long Goodnight-Loving Trail. On the third Goodnight-Loving Trail drive, Loving was scouting ahead of the herd when he and a companion were attacked by Comanches. He died of his wounds two weeks later. (New Mexico State University Library, Archives and Special Collections.)

John Simpson Chisum (1824–1884) started in the cattle business in 1854 in Texas and was one of the first to take advantage of the vast grazing land of northeastern New Mexico. In 1866, he joined with Charles Goodnight and Oliver Loving to provide cattle to feed Navajos being held at Bosque Redondo near Fort Sumner, New Mexico. (New Mexico State University Library, Archives and Special Collections.)

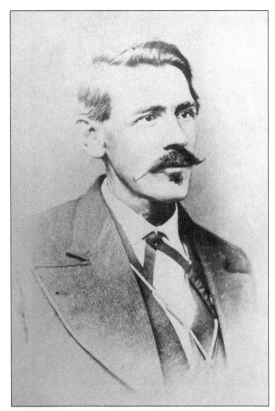

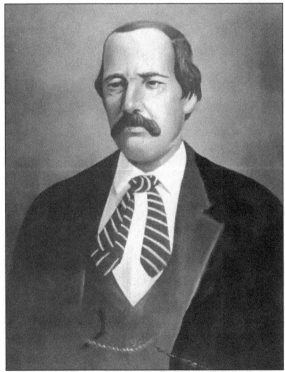

Lucien Bonaparte Maxwell (1818–1875) was a hunter with John C. Frémont's western expeditions in the 1840s. In 1842, Maxwell married Luz Beaubien (1829–1900), the daughter of one of the owners of the Beaubien-Miranda Land Grant. He eventually obtained through inheritance and purchase the entire 1.7 million acres and renamed the grant the Maxwell Land Grant. (Philmont Scout Ranch.)

Lucien Maxwell's son Pete Maxwell (1848–1898), pictured here, played an important role in the Lincoln County War in southeastern New Mexico. He was the person who informed Sheriff Patrick Floyd Garrett that William Bonney, known as "Billy the Kid," was at Maxwell's house at Fort Sumner, New Mexico. Garrett confronted Bonney there and killed him. (New Mexico State University Library, Archives and Special Collections.)

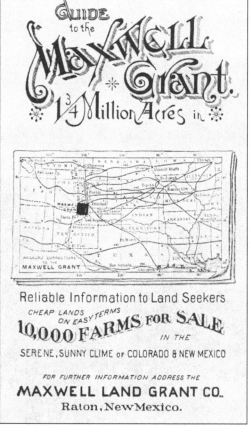

In 1870, a group of Colorado men, including the governor and a Colorado Supreme Court justice, along with investors from London, England, exercised an option to purchase the Maxwell Land Grant from Lucien Maxwell. They formed the Maxwell Land Grant Company. A year later, William Raymond Morley was hired to survey the grant boundaries. He also served as manager of the company. (Philmont Scout Ranch.)

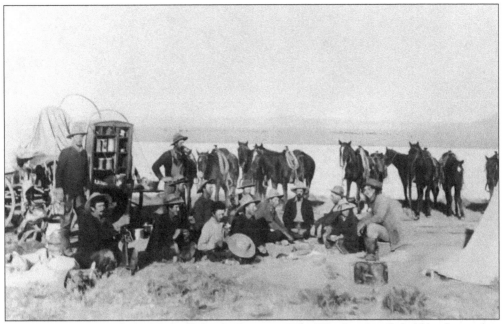

These cowboys are with the Maxwell Cattle Company. The Winchester rifle held by the cowboy seated at left was not carried when working cattle. The rifle, in a scabbard attached to the saddle, could catch a rope or reins, and the scabbard itself tended to rub the horse and the cowboy's legs. (Philmont Scout Ranch.)

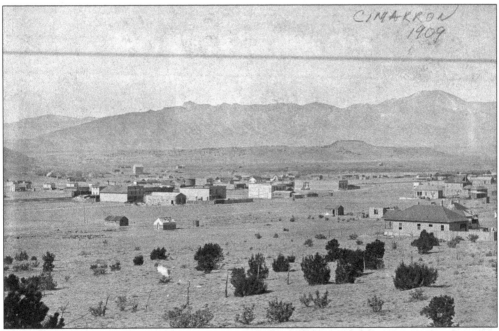

The town of Cimarron grew up around Lucien Maxwell's grant headquarters on the Cimarron River. The townsite was located on the Cimarron River in Colfax County. The tall building in the left rear in this photograph, taken in 1909, is Maxwell's Aztec Gristmill. (New Mexico State University Library, Archives and Special Collections.)

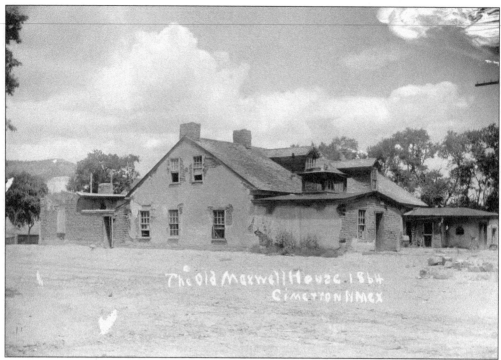

By 1858, Lucien and Luz Maxwell had relocated from land along the Rayado River, 11 miles south, to the banks of the Cimarron River. Here, Lucien built a complex of buildings, with one section for family living quarters and another section for accommodating visitors. The visitors' area also included space for drinking, dancing, and gambling. (New Mexico State University Library, Archives and Special Collections.)

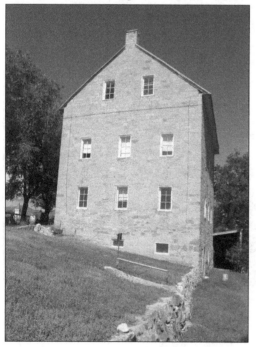

Lucien Maxwell built the four-story Aztec Gristmill in 1861 at a cost of $48,000, and by 1864, the mill was producing 44 barrels of flour daily. The mill featured an interior waterwheel, located on the ground floor of the mill. This allowed the mill to be operated year-round. Initially preserved by the Davis family of the CS Ranch, the building serves as a museum today. (Author's collection.)

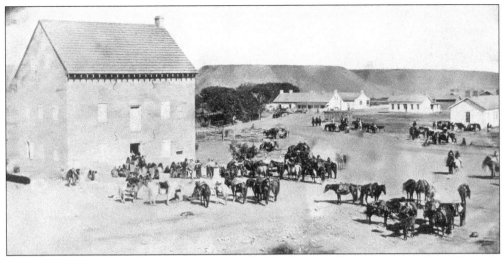

This photograph shows Lucien Maxwell's Aztec Gristmill in the foreground and his lavish adobe home in the background. This picture was taken on Indian Ration Day in 1868, when provisions like meat, flour, and blankets were distributed to Jicarilla Apaches from the surrounding area. The Indians can be seen gathered around the entrance to the mill. (New Mexico State University Library, Archives and Special Collections.)

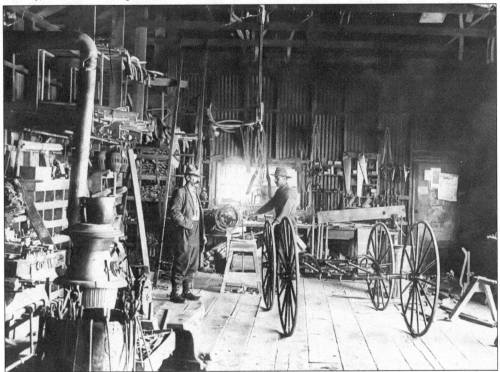

Most ranches maintained their own blacksmith facilities, but they were usually not as extensive as the Lail and Wilkins Blacksmith Shop, owned by James Thomas Lail (1869–1960), pictured on the left, and Norman Wilkins (1883–1964), pictured on the right, in Cimarron, New Mexico. Seen around 1910, a carriage has been brought into the shop for repair. (New Mexico State University Library, Archives and Special Collections.)

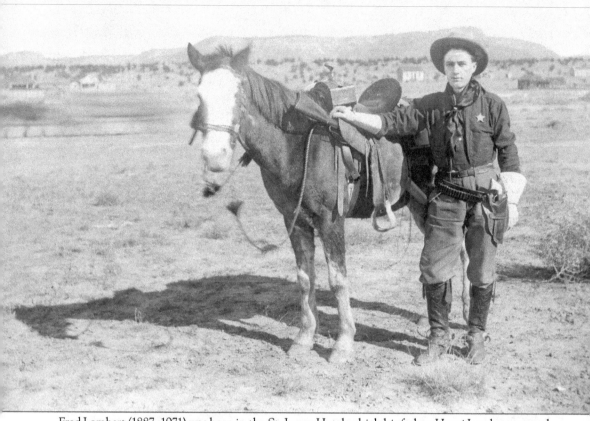

Fred Lambert (1887–1971) was born in the St. James Hotel, which his father, Henri Lambert, owned. When he was 16 years old, Fred was appointed deputy sheriff, and by himself captured two men and a woman wanted for a killing in Las Vegas, New Mexico. Although he was in law enforcement the rest of his life, Fred also maintained a small ranching operation near Cimarron. He is pictured here around 1907. (New Mexico State University Library, Archives and Special Collections.)

The validity of the Maxwell Land Grant was tested frequently in the courts, and violence, dubbed the Colfax County War, erupted between the legal owners of the grant and those individuals and families who had illegally occupied and developed homesteads and livestock grazing operations. The Rev. O.P. McMains (1840–1899), pictured at right, championed the squatters. (Philmont Scout Ranch.)

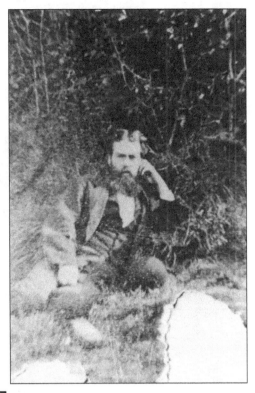

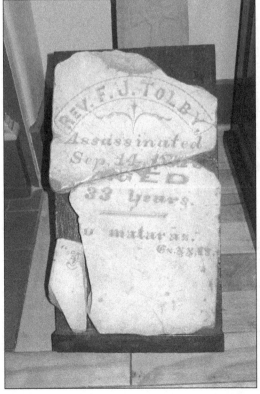

Rev. Franklin J. Tolby (1841–1875) was a Methodist circuit minister in Colfax County who campaigned for the return of the Maxwell Land Grant to the Utes and Apaches. He was an ally of O.P. McMain's in his opposition to the Maxwell Land Grant Company. Tolby was murdered on September 14, 1875. His often vandalized tombstone now rests in the lobby of the St. James Hotel. (Author's collection.)

17

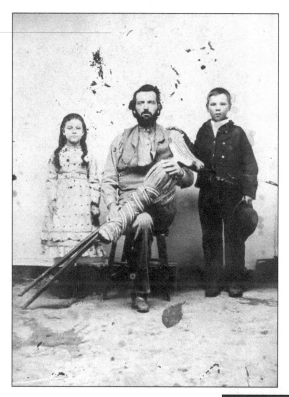

Clay Allison (1841–1887), a notorious Colfax County resident, is pictured here with his daughter, Patti Dora. The boy is unidentified. During the Colfax County War, Clay Allison took up the cause of Revs. F.J. Tolby and O.P. McMains opposing the Maxwell Land Grant Company and a confederacy of politicians and lawyers known as "the Santa Fe Ring." (New Mexico State University Library, Archives and Special Collections.)

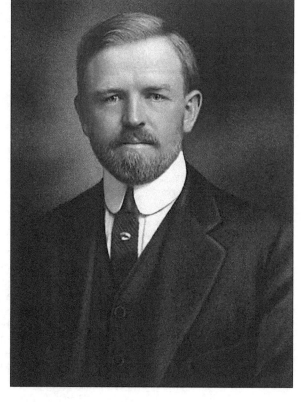

William Raymond Morley (1846–1883) was a business associate of Manly Chase. He was a partner with Chase, and served as engineer for the Atchison, Topeka & Santa Fe Railway and for the Maxwell Land Grant Company. In 1873, he married Ada McPherson, and they had three children—Agnes, Raymond, and Loraine. He was killed in 1883 in Santa Rosalia, Mexico. (Author's collection.)

Raymond Morley's eldest daughter, Agnes (1874–1958), married George Mason Chase in 1892. The marriage ended in divorce, and Agnes later married Norman Cleaveland. After the death of her father, her mother, Ada, remarried and moved to the Drag A Ranch near Datil, New Mexico, and Agnes and her brother, Ray, managed the ranch until the 1940s. (New Mexico State University Library, Archives and Special Collections.)

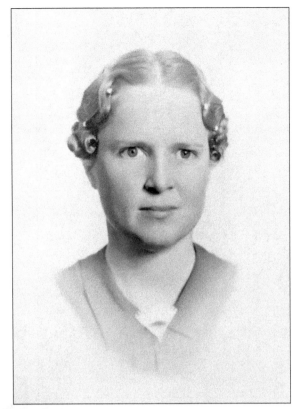

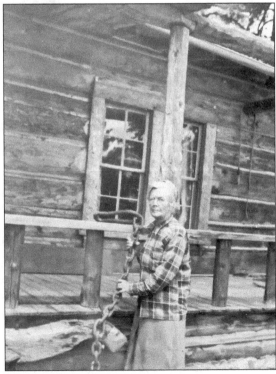

Agnes Morley Cleaveland, pictured here around 1950, is known for the book she wrote about ranch life, *No Life for a Lady*, published in 1941. A reviewer stated, "In this book you will find the West uncorrupted by Westerners; the cowboy before he knew he was picturesque; the Indian before he wore Levi Strauss overalls; the outlaw before Hollywood got him." (New Mexico State University Library, Archives and Special Collections.)

19

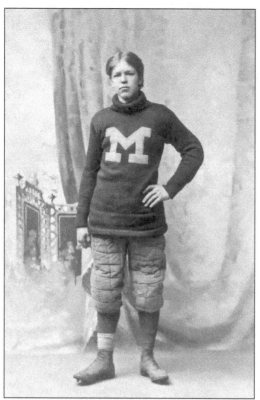

Two years younger than his sister Agnes, Ray Morley (1876–1932) helped his sister run the Drag A Ranch near Datil, New Mexico. He later attended the University of Michigan, where he was an outstanding athlete. He was one of the founders of the New Mexico Cattle Growers Association. (New Mexico State University Library, Archives and Special Collections.)

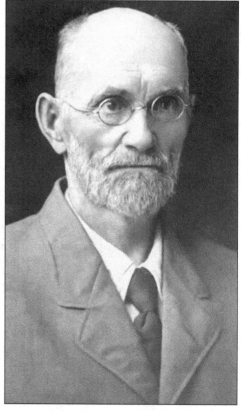

Manly Mortimer Chase (1842–1915) was originally from Wisconsin. After working in the merchant trade in Central City, Colorado, Manly and his wife, Theresa, crossed Raton Pass into northeastern New Mexico in 1867. They purchased land eventually totaling 25,000 acres from Lucien Maxwell just before he sold the majority of the Maxwell Land Grant to a group of promoters and speculators. (New Mexico State University Library, Archives and Special Collections.)

Theresa Wade Chase (1846–1900) married 18-year-old Manly Chase in 1860, when she was 14 years old. They were married for 40 years and had eight children. The first two, Margery Alice and David Kimball, died in infancy. The six other children were Lottie (1868–1893), George Mason (1870–1943), Laura (1872–1955), Ida Bell (1875–1912), Mary Lorraine (1877–1948), and Stanley Mortimer (1879–1954). (Author's collection.)

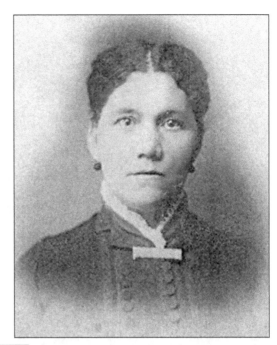

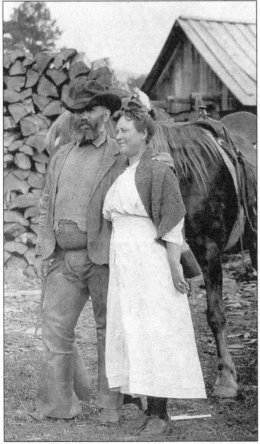

George Mason Chase (1870–1943), pictured here with his second wife, Henrietta, continued the Chase family ranching tradition, working his first roundup when he was 12 years old. Henrietta "Nettie" was from a ranching family herself and was an accomplished horseback rider and hunter. (New Mexico State University Library, Archives and Special Collections.)

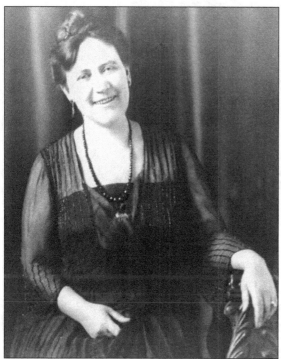

Nettie Curtis Chase (1880–1927) was the granddaughter of Joel Curtis, who drove herds on the Goodnight-Loving Trail in the early 1860s and, in 1867, bought land on the Vermejo River near Cimarron from Lucien Maxwell. Nettie often wore a necklace of large pearls to cover scars left on her neck when she was struck by lightning. (Philmont Scout Ranch.)

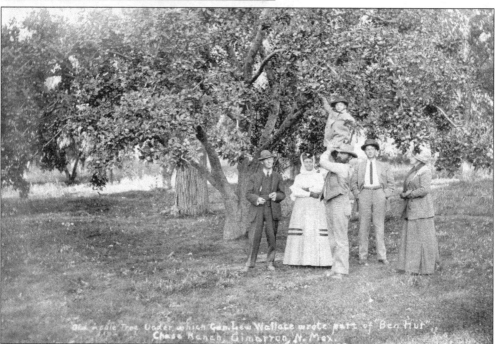

In addition to raising cattle, Mason and Nettie Chase also maintained an orchard of over 6,000 trees, shipping boxcar loads of fruit from the ranch. Oats, barley, and coal were also produced and shipped on the railroad. It is said that Gen. Lew Wallace, governor of New Mexico, wrote chapters of his epic best seller, *Ben Hur*, under this apple tree. (New Mexico State University Library, Archives and Special Collections.)

John W. Dawson (1868–1912) was a partner with Manly Chase in several enterprises including the Chase and Dawson Cattle Company, formed in 1873, and the Cimarron Cattle Company, formed in 1881. Other partners in the Cimarron Cattle Company were W.L. South, Frank Springer, H.M. Porter, and Taylor F. Maulding. Dawson is pictured here with his wife, Lavinia (1841–1923). (Old Mill Museum.)

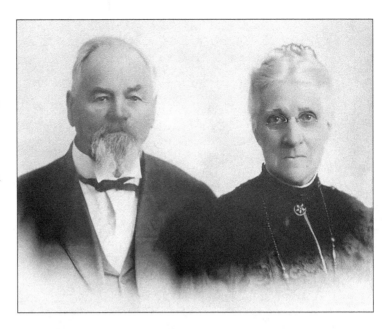

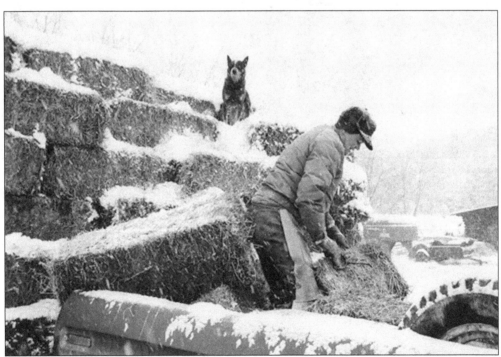

Gretchen Ann Sammis (1925–2012), shown here loading hay to feed to Chase cattle in the winter, was Manly Chase's great-granddaughter. Her mother, Margaret Lee Chase, first married Fred Sammis and later married Tommy Rupert. Gretchen taught school in Cimarron in addition to owning and operating the Chase Ranch with her partner, Ruby Gobble, until her death in August 2012. (Steve Zimmer.)

Pictured here are Ruby Gobble (1930–2013) (left) and Gretchen Sammis (right) at Chase Ranch. In 2013, a lease and operating agreement, established by Sammis prior to her death, was initiated between the Chase Ranch Foundation and Philmont Scout Ranch. Philmont is responsible for the preservation of the various ranch structures and the development of educational programs for Philmont participants as well as the general public. (Steve Zimmer.)

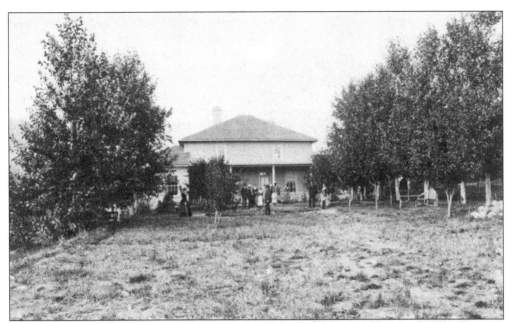

The original portion of the Chase Ranch ranch house (pictured here in 1881) was built by Manly Chase in 1872. It has been occupied continuously by four generations of the Chase family, most recently by Manly's great-granddaughter Gretchen Sammis and her partner Ruby Gobble. Pictured here is a croquet party on the lawn of the ranch house in 1881. (Old Mill Museum.)

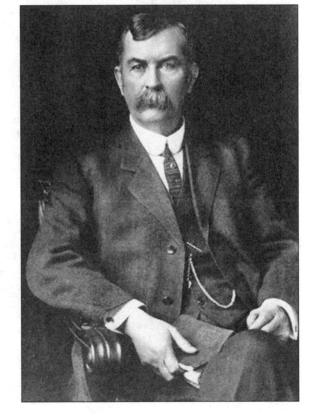

Frank Springer (1848–1927), along with his brother Charles, founded the CS Ranch near Cimarron in Colfax County in 1873. Frank served as the attorney for the Maxwell Land Grant Company and argued successfully before the US Supreme Court for the legitimacy of the grant and the establishment of the grant boundaries in 1887. This photograph was taken by Forest Gahn. (Philmont Scout Ranch.)

Charles Springer (1858–1932) was Frank Springer's brother and partner in the CS cattle ranch. The ranch took Charles's initials as its namesake. The ranch includes 130,000 acres that were once part of the 1.7-million-acre Maxwell Land Grant. Charles was married to two of Manly Chase's daughters, wedding Lottie in 1884 and Mary Lorraine in 1899. (New Mexico State University Library, Archives and Special Collections.)

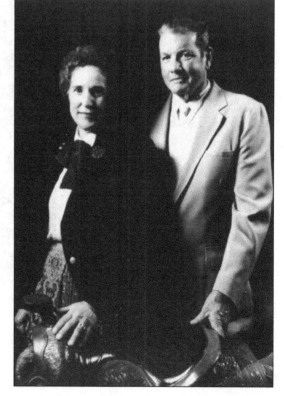

J. Leslie Davis (1919–2001) was the grandson of Frank Springer. In 1946, after distinguished military service during World War II, Les Davis became the manager of the CS Cattle Company, and in 1964 was elected president of the company. Under the stewardship of Les and his wife, Linda Mitchell Davis (1930–), the ranch grew to include about 200,000 acres supporting 2,800 head of cattle. (Herzstein Memorial Museum.)

Will James (1892–1942) was broke and recovering from a serious head injury suffered in a horse wreck in Reno, Nevada, in 1922. He ended up in the Santa Fe art colony, where he met Frank Springer's son Wallace. Wallace Springer hired James to work at the CS Ranch, where Ed Springer, Wallace's uncle, recognized his literary and artistic talents and financed his education at Yale University. James went on to become one of the best-known Western authors and illustrators. He is shown here with his favorite horse, Big Enough. (Philmont Scout Ranch.)

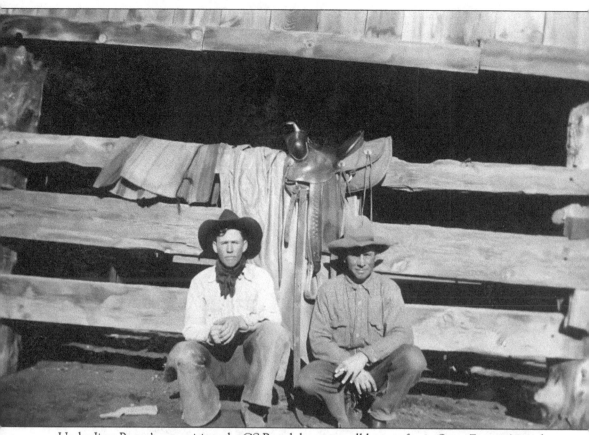

Under Jiggs Porter's supervision, the CS Ranch became well-known for, in Steve Zimmer's words, "big, stout colts with good heads and kind eyes." Jiggs had his own favorite horses as well. Ranch owner Ed Springer wanted to sell one of Jiggs's favorites and asked him to bring the horse to headquarters. Jiggs stalled and finally said the horse had come up lame and was not fit to ride. Springer then said, "If the horse means that much to you, you can ride him for a while longer." Jiggs is pictured here (on the left) with Maurice Pachta (1894–1971) in the corral at the CS Ranch. (Steve Zimmer.)

Jiggs Porter (1916–2005) was foreman of the CS Ranch from 1933 to 1999, first signing on when he was 17 years old. Jiggs served with the 27th Infantry Division in the Pacific during World War II. Les Davis made him general foreman of the CS Ranch in 1948. Jiggs lived at Crow Creek, on the CS Ranch, and considered himself a ranch employee until the day he died. (Steve Zimmer.)

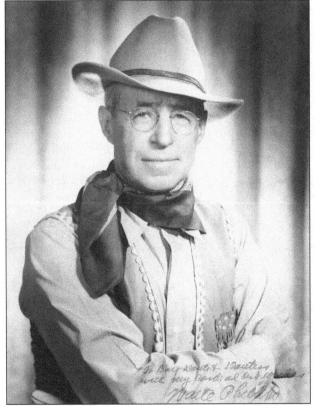

Waite Phillips (1883–1964), an oilman from Tulsa, Oklahoma, purchased the UU Bar Ranch in the early 1920s. In 1925, he renamed the ranch Philmont. Over the next several years, Phillips was able to purchase additional adjoining ranch land until he had acquired almost 300,000 acres by 1932. (Philmont Scout Ranch.)

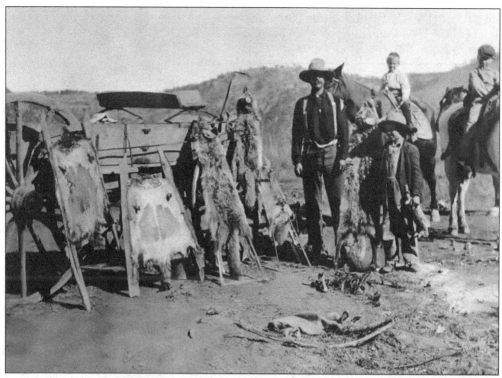

Lion and wolf hunting was necessary to protect livestock on ranches in Colfax County. These hunters in Ponil Canyon around 1920 worked for Urraca Ranch, which was purchased by Waite Phillips in 1922. Ultimately, Phillips acquired more than 300,000 contiguous acres of ranch land in Colfax County. (Philmont Scout Ranch.)

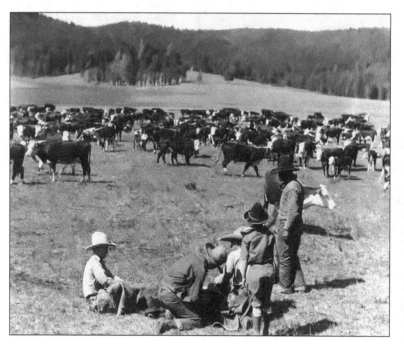

Branding on Philmont Ranch in the 1930s was a big job. The young cowboy in the black hat (with his back to the camera) is Waite Phillips's son Elliott, whose nickname was "Chope." This branding is taking place at the La Grulla Cow Camp on Philmont Ranch. (Philmont Scout Ranch.)

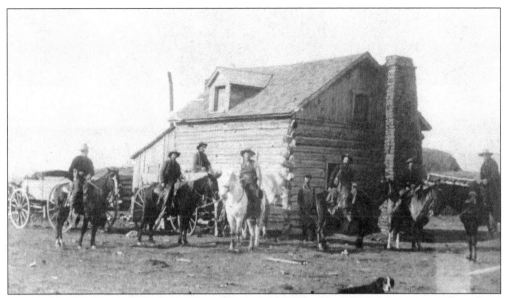

Founded by Manly Chase and John Dawson in 1875, Crow Creek Ranch was originally a sheep operation. In 1885, it became part of the Maxwell Cattle Company range, and it was later purchased by Waite Phillips. Today, the land is part of the CS Ranch. The man on the white horse is Marion Littrell, who was the ranch foreman for Chase and Dawson. (Philmont Scout Ranch.)

Elliott "Chope" W. Phillips (1918–2014) was given his nickname by Melaquias Espinosa, a Philmont Ranch cowboy. It was based on the Spanish word *chopo*, which means "short in stature, or shorty" in New Mexican Spanish. Some of his cousins corrupted it to "Chope," which he says he liked better than Elliott. He later owned the Watrous Valley Ranch south of Springer, New Mexico. (Philmont Scout Ranch.)

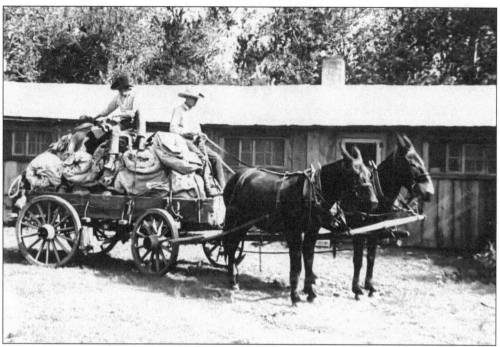

Chope Phillips is shown here atop the bed wagon at Zastrow, getting ready to go to La Grulla Cow Camp in 1938. Walter Calhoun is at the reins of the mule team. The bedroll not only provided a place to sleep but also served as a suitcase for all of a cowboy's personal items as well. (Philmont Scout Ranch.)

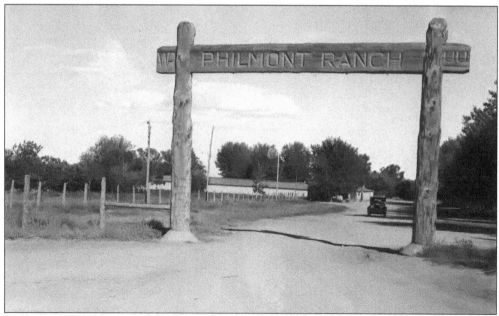

In 1938, Waite Phillips donated 35,837 acres of the northern portion of Philmont Ranch to the Boy Scouts of America. A second gift in 1941 brought the total donation to 127,395 acres. Initially named the Philturn Rockymountain Scoutcamp, the property was later renamed Philmont Scout Ranch. In 2014, the millionth Scout hiked the ranch's trails. (Philmont Scout Ranch.)

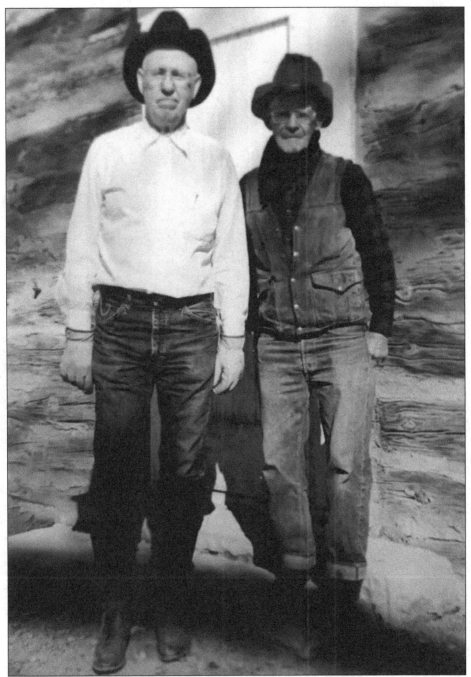

George "Shorty" Murray (1897–1993) was typical of many cowboys who worked on the ranches near Cimarron, in that he worked cows on more than one ranch in the area. At various times, Shorty worked on the Chase Ranch, the CS Ranch, the UU Bar Ranch, and Philmont Ranch. Steve Zimmer said that he was "a little man with a big heart possessed of a cowboy's affection for kids and animals of all kinds." Murray (on the right) is pictured here with Jiggs Porter. They are standing in front of the restored Horn cabin, built in 1854, located on CS Ranch property. (Philmont Scout Ranch.)

Melaquias Espinosa worked for many years for Waite Phillips as a cowboy at Philmont Ranch. At any given time, the ranch employed about 50 people, including cowboys, sheepherders, farmworkers, maintenance workers, and office personnel. Employees with families were provided with a house, supplies for a garden, and chickens. The ranch also provided beef and pork for all employees. Melaquias Espinosa was the man who gave Elliott "Chope" Phillips his nickname. (Philmont Scout Ranch.)

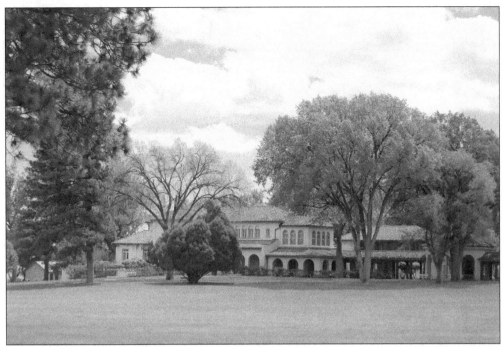

Referred to as "the Big House," Villa Philmonté was completed in the summer of 1927 and featured carefully landscaped grounds, a swimming pool, and a separate two-story guesthouse. Villa Philmonté was included in Waite Phillips's gift of land to the Boy Scouts of America in 1941. (Author's collection.)

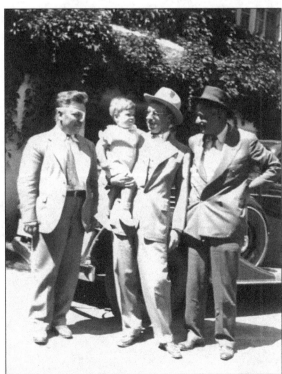

Waite Phillips entertained many famous guests at Philmont Ranch during the 1920s and 1930s, including Charles Gates Dawes, the vice president under Calvin Coolidge. Pictured at Villa Philmonté are, from left to right, aviator Wiley Post; Phillips's eldest grandson, Phillips Breckenridge; Phillips; and humorist Will Rogers. Rogers and Post flew to Philmont Ranch in a small plane in August 1935. (Philmont Scout Ranch.)

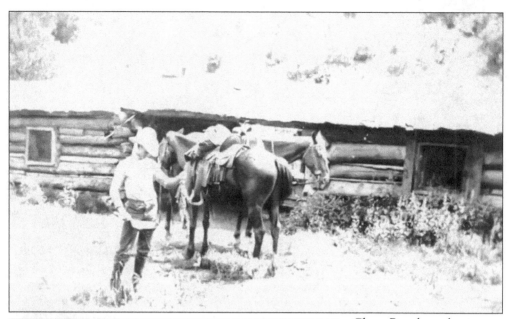

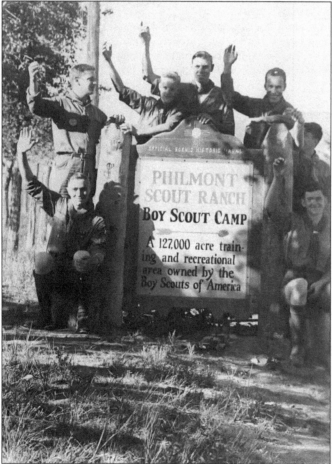

Chase Ranch cowboy Tommy Rupert (1903–1975) also worked for Waite Phillips at the Philmont Ranch. He is shown here at Ponil preparing a rabbit for the frying pan. Tommy Rupert married Stanley Chase's daughter Margaret Lee and was stepfather to Gretchen Sammis and her sister, Joan. (Philmont Scout Ranch)

In 1938, Waite Phillips donated 35,000 acres of his Philmont Ranch to the Boy Scouts of America. That parcel was named Philturn Rockymountain Scoutcamp. In 1941, shortly after the Japanese attack on Pearl Harbor, Phillips donated an additional 91,000 acres, along with the Villa Philmonté ranch house. In 2014, Philmont hosted the one millionth Scout to hike and ride the ranch's trails. (Philmont Scout Ranch.)

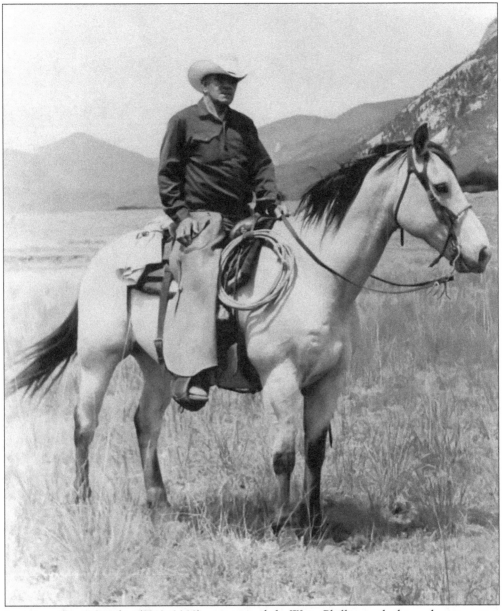

Lawrence "Boss" Sanchez (1918–2008) went to work for Waite Phillips in the horse department at Philmont Ranch in 1938. When the ranch was donated to the Boy Scouts of America, Sanchez said he would stay with the ranch "for a while" to help the Scouts learn horsemanship the right way. He retired after 45 years at Philmont in 1983. Boss got his nickname shortly after he signed on at Philmont Ranch, when he was out with a crew mending fence. The ranch foreman was called away, and he said to Lawrence, "You can boss this crew until I get back." Of course, the cowboys picked up on this and began calling him "Boss" just to get his goat. The name stuck, and he was called Boss Sanchez from then on. (Philmont Scout Ranch.)

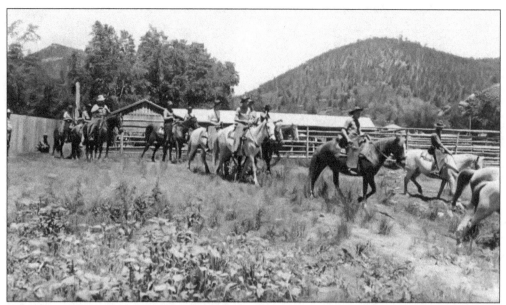

These Boy Scouts are among the first to experience the beauty of Waite Phillips's Philmont Ranch. They are riding a trail at what was then called Philturn Rockymountain Scoutcamp in 1939. Each expedition or trek included 8 to 10 days of hiking, horseback riding, and camping in the Philmont backcountry, a true wilderness experience. (Philmont Scout Ranch.)

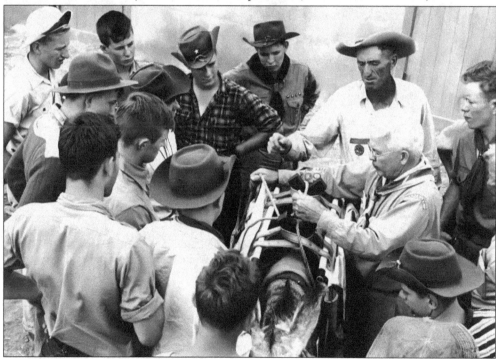

Philmont Scout Ranch cowboy Lee Edward "Booger" Brown (1925–2005) is showing these Boy Scouts how to position a pack saddle on a burro in this photograph taken in the 1950s. Brown worked for Waite Phillips at Philmont Ranch and stayed on after the ranch ownership passed to the Boy Scouts of America. (Philmont Scout Ranch.)

The iconic landmark Tooth of Time, a spectacularly weathered outcrop along the Tooth of Time Ridge, is shown here from Crater Lake camp at Philmont Ranch. The Tooth of Time dominates the Cimarron Range in Colfax County. (Philmont Scout Ranch.)

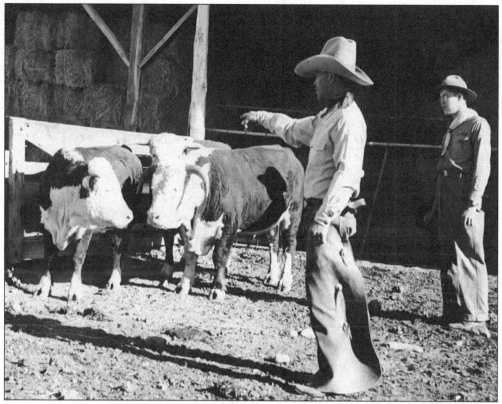

Philmont cowboy Shorty Martinez points out features of some of the ranch's Hereford bulls to a Service Corps Scout in 1943. Philmont Scout Ranch maintains an active cattle operation to the present day. The addition of the Chase Ranch property lease agreement means that Philmont can provide a unique ranch experience for Scouts. (Philmont Scout Ranch.)

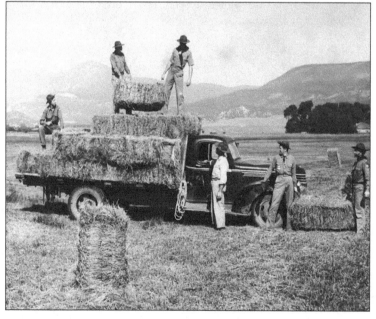

During World War II, the camping season at Philmont Scout Ranch was very limited. Scouts were encouraged not to come to the ranch due to wartime travel restrictions, so only a few campers came to the property. Those who did come were formed into a Service Corps and put to work on projects throughout the ranch. These Service Corps Scouts are gathering hay. (Philmont Scout Ranch.)

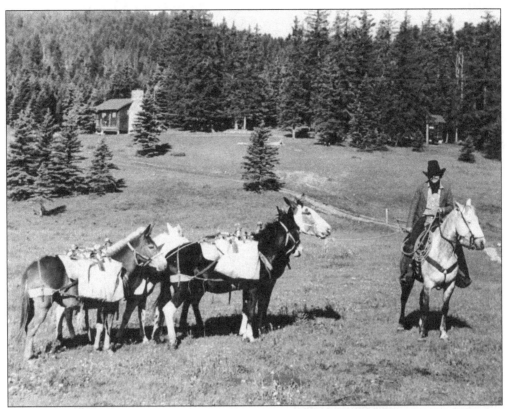

This photograph, taken sometime in the 1970s, shows Philmont Scout Ranch wrangler Robert Dan Juden with a string of mules. The packsaddles contain provisions destined for one of the ranch's more remote base camps. Bob Juden performed as a country-and-western musician, at one time singing with well-known cowboy recording artist R.W. Hampton. (Philmont Scout Ranch.)

GUIDE BOOK TO
Adventure

PHILMONT SCOUT RANCH P2
and
EXPLORER BASE
/2 CIMARRON, NEW MEXICO

During camping expeditions, called treks, at Philmont Scout Ranch, Boy Scouts from all over the world learn outdoor skills such as map reading, compass navigation, burro packing, marksmanship, horseback riding, and outdoor cooking. At one camp, called Indian Writings, Scouts participate in the archaeological excavation of a Paleo-Indian site. (Author's collection.)

Waite Phillips had this tribute to the UU Bar Ranch, which he owned, painted on one of the fireplaces at Villa Philmonté, the ranch house he built at his Philmont Ranch. When Phillips donated 137,000 acres of his ranch holdings, the UU Bar was the only portion he maintained possession of. (Author's collection.)

Robert A. Funk (1939–) purchased the Altmore Ranch in 1996. Altmore Ranch was surrounded by Philmont Scout Ranch, and Funk's purchase preserved the ranch intact and prevented it being broken up into a 20-acre parcel subdivision. In 2006, Funk purchased the nearby UU Bar Ranch from Brad Kelley. (Express UU Bar Ranch.)

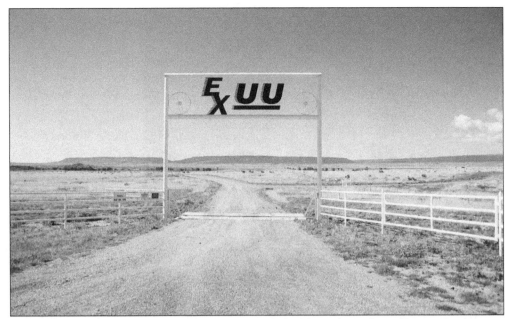

Today, the UU Bar Ranch is owned by Robert A. Funk, founder and president of Express Employment Professionals. The ranch is now called the Express UU Bar. In addition to continuing the cattle-raising tradition established by Waite Phillips when he owned the ranch, the Express UU Bar Ranch also provides hunting, fishing, and guest lodging facilities. (Author's collection.)

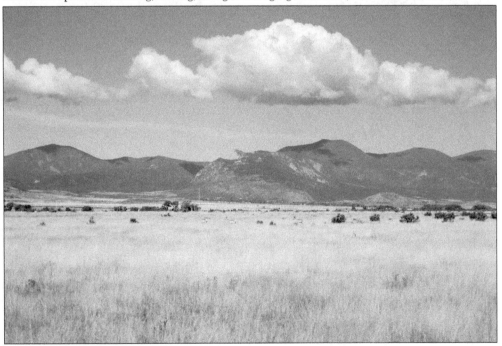

The Tooth of Time can be seen from this grama grass pasture on the UU Bar Ranch. A small herd of pronghorn antelope can also be seen in this photograph. Waite Phillips wanted the WP brand for the ranch, but it was already being used. Instead, he split the W in his first name into two Us and added a bar to form the brand. (Author's collection.)

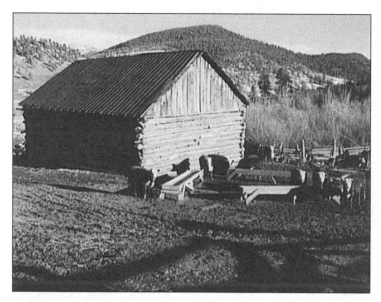

George Mutz's ranch in the Moreno Valley, near Elizabethtown, New Mexico, was photographed by John Collier, with the Farm Security Administration's (FSA) Historical Section in 1943. This shows the log barn and feed pens at the ranch. The ranch contained about 16,000 acres, and additional acres were leased from the Maxwell Land Grant Company. (Library of Congress.)

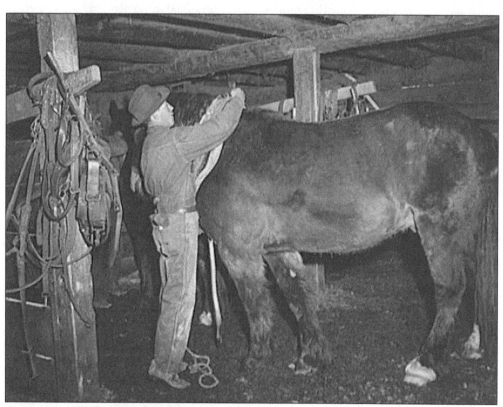

George Mutz (1893–1974) is shown in this 1943 John Collier photograph harnessing a horse in the log barn at Mutz Ranch. The team of horses will be hitched to a wagon to haul hay to cattle on winter pasture. George's father, Herman Mutz, came to New Mexico from Germany in 1882, when he was 19 years old. (Library of Congress.)

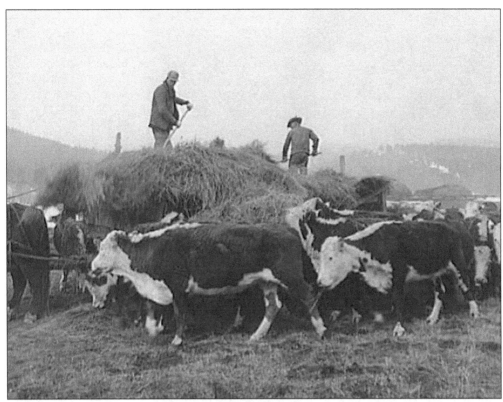

Winters can be severe in the Moreno Valley in Colfax County, and supplemental feeding is required to keep the cattle healthy. Hay from a horse-drawn wagon is being thrown to Hereford cattle at the George Mutz ranch in this February 1943 photograph by John Collier. (Library of Congress.)

Everybody works on a ranch. Here, George Mutz's daughter Mary is shown holding a herd of cattle in place on the Mutz Ranch in the Moreno Valley, Colfax County, New Mexico, in 1943. (Library of Congress.)

45

Cow-calf operations are dominant throughout northeastern New Mexico. On such ranches, a permanent herd of cows is maintained to produce calves for later sale. Calves may be sold soon after they are weaned, or they may be retained and grass fed at the ranch for one or two years and then sold. This cow-calf "unit" was photographed on the Mutz Ranch. (Library of Congress.)

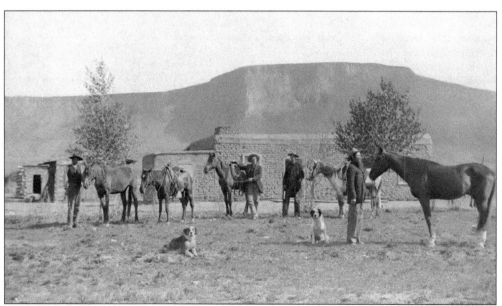

TO Ranch founder Antime Joseph "Tony" Meloche (1837–1916) was a native of Quebec, Canada. At one time, the TO Ranch had over 1,000 head of cattle and between 400 and 500 head of horses. Tony Meloche is shown in the right foreground of this 1885 photograph with a favorite horse, Sweeper. (Raton Museum Collection.)

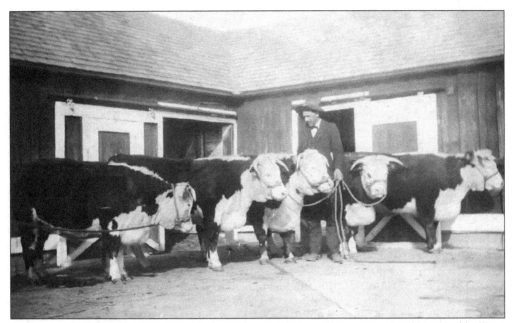

Anthony J. Meloche Jr. (1875–1927) is shown here with five of his top purebred Hereford bulls. A 1907 history of New Mexico includes the following about him: "Since coming into possession of his ranch, Mr. Meloche has continuously carried on general farming and stock raising, developing a business of considerable importance and becoming one of the well-known ranch men of the territory." (Raton Museum Collection.)

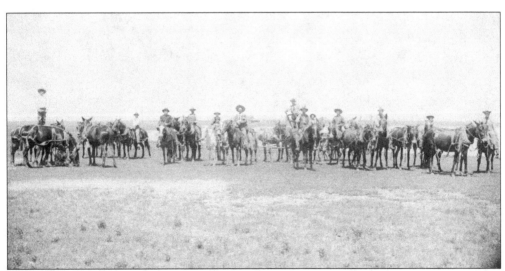

TO Ranch cowboys are shown here in this 1880s photograph by Phillips and Gallaher. These horse and mule teams will be hitched to hay wagons. The hay will be used as winter feed. Since 1999, the ranch has been owned by John C. and Leslie Malone. (Raton Museum Collection.)

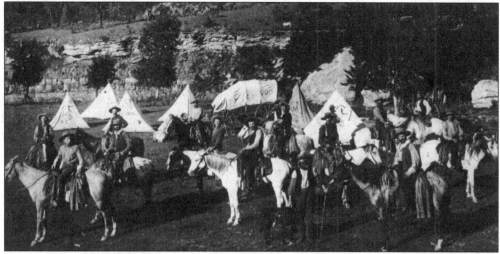

These cowboys, photographed in 1887, are getting ready for the spring roundup on the TO Ranch. Cowboys from neighboring ranches gathered to help with the roundup. During the days of the open range, once gathered, calves were allowed to "mother up" and were branded with the same mark as the mother cow. They were then separated by ranch brand and driven to their home ranges. (Raton Museum Collection.)

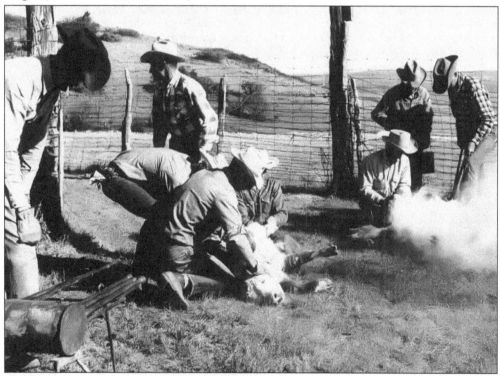

The TO Ranch grew to more than 200,000 acres and developed prizewinning Hereford cattle. Pictured here in 1959 are, from left to right, Ernest Padilla at the branding-iron fire, Mike Cunico standing looking left, Ben Pruett bending to vaccinate, Gilbert Lopez and Richard Tondrow flanking the calf, Possum Brown and Claudio Aragon flanking second calf, and Karl Herron branding. (Raton Museum Collection.)

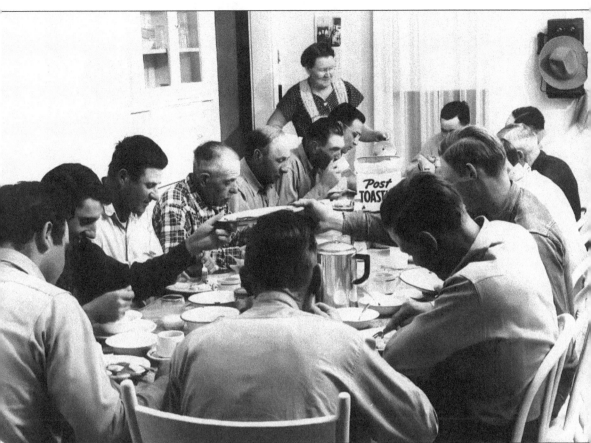

Breakfast at the TO Ranch in May 1952 was at 5:00 a.m. Shown clockwise in this photograph are, from the head of the table, Bill House, Slim Miller, Billy Howard, Possum Brown, Ed Kinsey (hidden), Jim Stantley, Carl Reed, Lester Popejoy, Banjo Elwess, Jack Bechdol, George Kapich, Adolph Maes, Maurice Pachta (who also worked with Jiggs Porter at the CS Ranch), Ben Pruett, Harry Gatlin, and the cook, Eva Nolin. (Raton Museum Collection.)

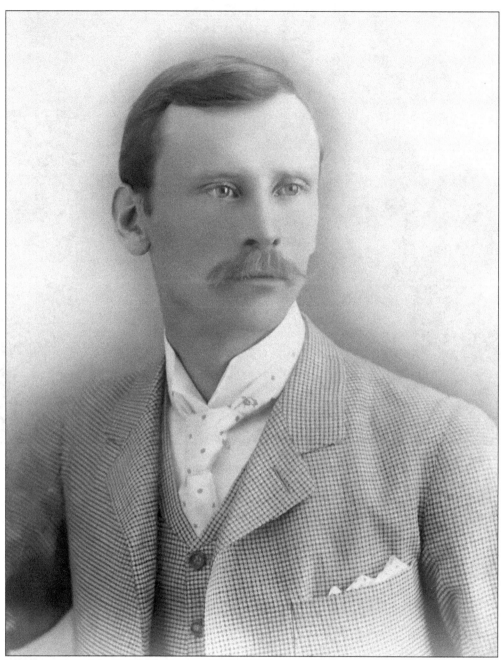

Montague Farquhar Sheffields Stevens (1859–1953) was an Englishman who was born in India. He first came to New Mexico on a hunting trip in 1879, and in 1882 returned to live in New Mexico the rest of his life. He owned several ranches in the state, including the 125,000-acre WS Ranch in Colfax County, which he purchased with Scottish native Harold C. Wilson. The ranch name was a combination of the initials for Wilson and Stevens. Stevens owned as many as 20,000 cattle and 16,000 sheep and was known throughout the West as a great hunter. He accomplished all of this in spite of having lost an arm in a hunting accident. (Suzanne Smith, the Joseph E. Smith Collection.)

Two

THE HISTORIC RANCHES OF HARDING COUNTY

Harding County was created from parts of Union and Mora Counties on the day Warren G. Harding was inaugurated president, March 4, 1921. At that time, 5,000 people lived in the county. However, with only 695 residents according to the census of 2010, Harding County is the most sparsely populated county in New Mexico. The dramatic Canadian River Canyon lies along Harding County's western border with Mora County, and the southwest border adjoins the Bell Ranch in San Miguel County.

Thomas Edward Mitchell came from Colorado to the Tequesquite Valley in Harding County in 1881, and he acquired a portion of the Bar T Cross Ranch in 1896. He started what is believed to be the first herd of registered Hereford cattle in New Mexico. T.E. Mitchell ran the Tequesquite Ranch with his son Albert K. Mitchell. Beginning in 1933, Albert also managed the Bell Ranch in San Miguel County, in addition to running the Tequesquite. Albert's daughter Linda married Les Davis, grandson of Frank Springer, and together the two of them managed the CS Ranch in Colfax County.

In 1933, Celestin Joseph "Frenchie" Clavel founded the Twin Creek Ranch, northeast of Roy. Frenchie died in 1940, leaving his wife, Bernice, his 17-year-old son Jodie, and his 9-year-old son Calvin to run the ranch. Twin Creek Ranch is still run by the Clavel family today, with the fifth generation working cattle on horseback.

Stephen Brock, Harding County extension agent, purchased the DeHaven Ranch, located near Yates, shortly after World War II. He and his wife, Jean, ran the ranch until she passed away in 1996. Stephen died in 2002, and the ranch is managed today by Stephen and Jean's daughter Stephanie Brock.

Celestin Joseph Clavel II (1877–1940), known as "Frenchie," came to the United States from France with his father in 1889. He worked for the railroad, and he began to acquire some ranch land during the 1920s. It was while working for the railroad that Frenchie met Bernice Lane (1892–1981), and they were married in 1910. He founded Twin Creek Ranch in Harding County in 1933. (Clavel family.)

Celestin Joseph Clavel II caught pneumonia and died in 1940. At the same time, a flood destroyed the Twin Creek ranch house. Bernice Lane Clavel, pictured here, was forced to build a new house in the few months before winter, with only her sons, 17-year-old Jodie and 9-year-old Calvin, to help. Bernice, Jodie, and Calvin then assumed the work of running the ranch. (Clavel family.)

When Jodie Clavel (1923–), pictured here with a favorite horse, Peanuts, was 10 years old, the family was living in Tucumcari, New Mexico. His father, Frenchie, had purchased the land at Twin Creek ranch in Harding County, but there were no cattle and the family was not living at the ranch. Frenchie ordered several railcar loads of heifers delivered to Tucumcari and then told Jodie to drive the cattle from Tucumcari to the ranch north of Roy, New Mexico. Jodie did as he was told and delivered every one of the cows to the Twin Creek Ranch, single-handedly completing a cattle drive of over 100 miles. (Clavel family.)

Jodie Clavel is pictured here in 1938 on Bennie. By age 20, Jodie was managing the Twin Creek Ranch full-time, with help from his younger brother, Calvin, and his mother, Bernice. (Clavel family.)

Jodie, left, and his younger brother, Calvin, right, worked together to make Clavel's Twin Creek Ranch a productive cow-calf operation. They erected several windmills and laid miles of pipeline to provide water for not only the cattle and wildlife but also for those living at the ranch. They are shown here during a horse-breaking session. (Clavel family.)

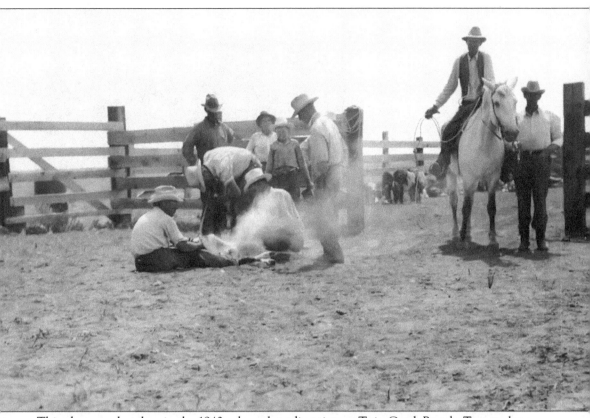

This photograph, taken in the 1940s, shows branding time at Twin Creek Ranch. Two cowboys are flanking, or holding, the calf while another applies the branding iron. The mounted cowboy is waiting to rope another calf by the heels and drag it to the branding area. (Clavel family.)

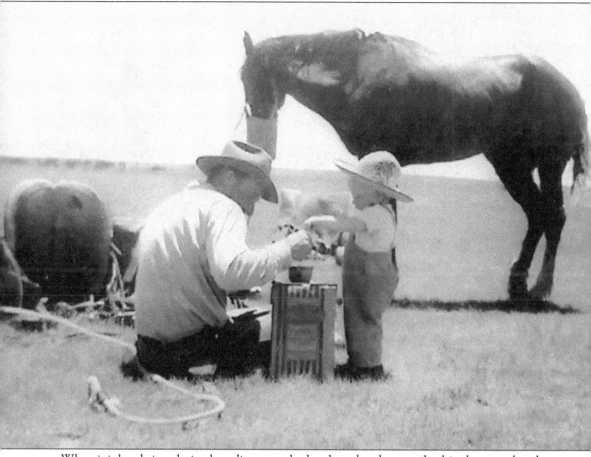

When it is lunchtime during branding, everybody takes a break to eat. In this photograph, taken in 1949, Jodie Clavel, his son Joe Clavel, and even the horse, Bennie, all tie on the feedbag. Jodie's son Joe assumed ranch chores from the time he could walk. (Clavel family.)

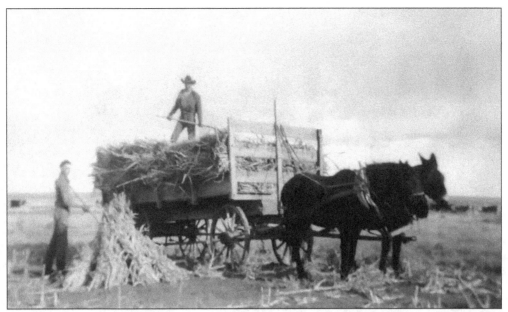

Jodie Clavel, left, and Brian Dennis are loading the wagon with bundles of redtop cane, gathered into shocks in the field on Twin Creek Ranch. Field crops were raised at Twin Creek to provide supplementary winter feed for the cattle. (Clavel family.)

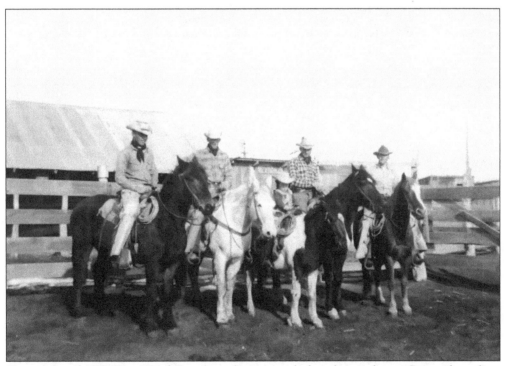

Shown around 1950, Twin Creek Ranch cowboys are with their favorite horses. Pictured are, from left to right, George Vinall on Blackie, Jim Vinall on Blue Jay, Joe Clavel on Tango, Jodie Clavel on Bennie, and Calvin Clavel on Torpedo. (Clavel family.)

As shown in this photograph, taken around 1950, Joe Clavel, the third generation at Twin Creek Ranch, was comfortable around horses and cattle from his first days. Today, the fifth generation of Clavels is still working cattle on horseback at the ranch, maintaining a successful cow-calf operation. Twin Creek Ranch has also developed a registered Hereford herd. (Clavel family.)

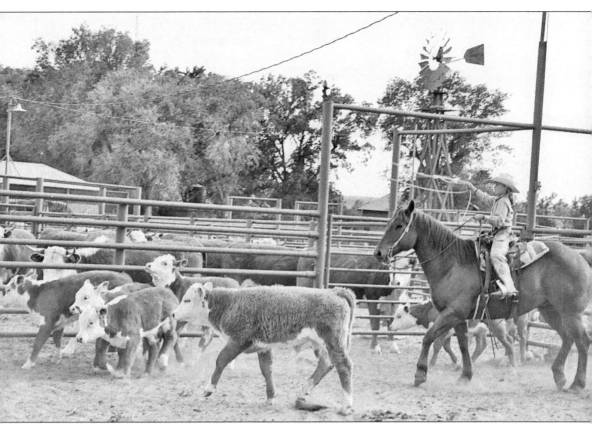

Nine-year-old Riley Jo Clavel is going about her business roping calves at Clavel's Twin Creek Ranch in Harding County. She is a member of the fifth generation of Clavels to work cattle on horseback at this historic ranch. This photograph was taken in 2014. (Clavel family.)

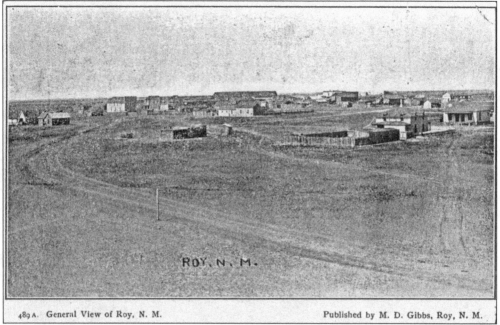

489 A. General View of Roy, N. M. Published by M. D. Gibbs, Roy, N. M.

The town of Roy, New Mexico, pictured here around 1910, was named for Frank Roy (1864–1938), who settled in the area in 1901. Roy is located about midway between Wagon Mound, in Mora County, and Clayton, in Union County. (New Mexico State University Library, Archives and Special Collections.)

The population of Roy, New Mexico, peaked around 1940 at nearly 1,200 residents. The town of Roy continues to be an important commercial and civic center for the ranching families of northeastern New Mexico. Notable residents of Roy have included professional football player Tommy McDonald and Western swing bandleader Bob Wills, who served as the town barber for many years. (Author's collection.)

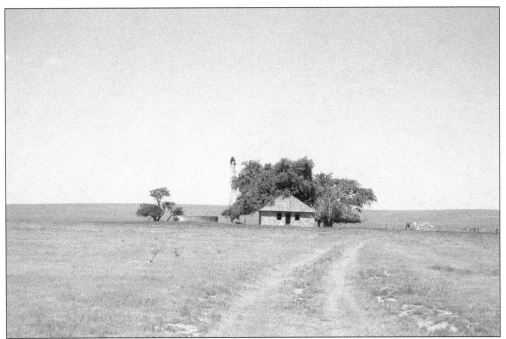

This is a typical Harding County homestead, located on New Mexico Route 120 northeast of Roy, New Mexico. Even if the house were no longer standing, which is typical of most homesteads in the county, this location could be identified as a homestead site by the presence of a windmill and trees. (Author's collection.)

This is typical of the vast grama grass pasturage found in Harding County. This photograph was taken during a period of relatively abundant rainfall, but that has not always been the case. Always at the mercy of the weather (every rancher's partner), the ranches of northeastern New Mexico have endured many crippling droughts. It is easy to see why this country has been called "the Big Empty." (Author's collection.)

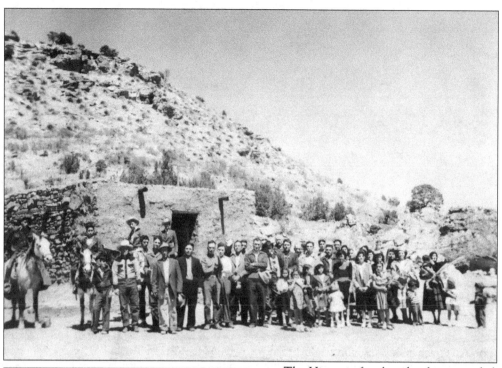

The Hispanic families that homesteaded in Harding County formed a strong religious community, even in the absence of ordained priests. A lay brotherhood, called the Penitentes, built churches and conducted services. Pictured here in front of the Penitente morada, around 1930, is the congregation gathered after Good Friday services. (Dorothy Valdez.)

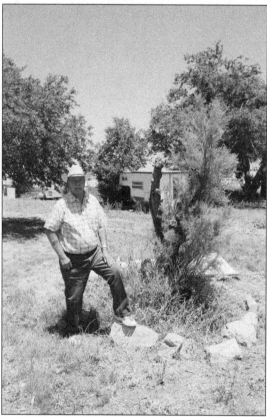

George Lovato's family homesteaded in Harding County, beginning in the early 1930s. Members of the family still run cattle on the L Bar 9 Ranch today. George conducts tours of Harding County homesteads and provides information about the families who lived there. He is pictured here standing next to a tamarisk tree he planted with his grandmother in the late 1940s. (Author's collection.)

Stephen L. Brock (1915–2002) was the county agent for the Cooperative Extension Service in Harding County during the difficult Depression and dust bowl years. He commanded a group of tank landing ships (LSTs) on D-day and later purchased the DeHaven Ranch near Yates in Harding County from the Harlan family. Brock was elected to the New Mexico State Senate in 1952. (Stephanie Brock)

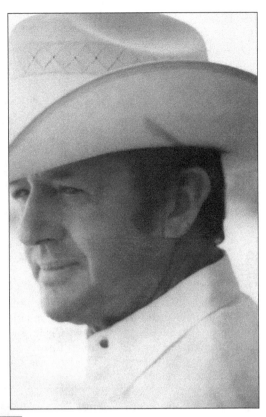

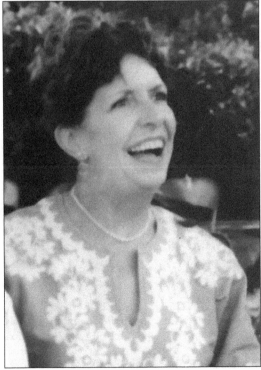

Jean Humphrey Brock (1922–1996) married Stephen L. Brock in 1948. A native of Wichita, Kansas, and a mathematics graduate of Wichita State University, she met Brock during World War II. She adapted to country life in Harding County, New Mexico, raised three daughters, and in her mid-50s returned to the workforce as a math teacher in the Wagon Mound Schools. (Stephanie Brock.)

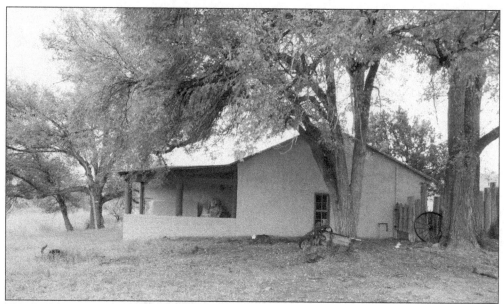

This building was constructed on the foundation of the original DeHaven Post Office, named for the first postmaster, George W. DeHaven, who served from 1895 to 1920. It now serves as the bunkhouse for the DeHaven Ranch. The DeHaven Ranch was originally part of the 1882 Jesus Lucero homestead. The land was purchased by Stephen L. Brock in the late 1940s. (Author's collection.)

The main ranch house at DeHaven Ranch is a combination of structures built over many decades. Several of the walls of the building are two feet deep and are made of rock and adobe. The most recent addition was built in 1959 of concrete block. The addition was supervised by Harold Littlefield, a master builder from Santa Fe, New Mexico. (Author's collection.)

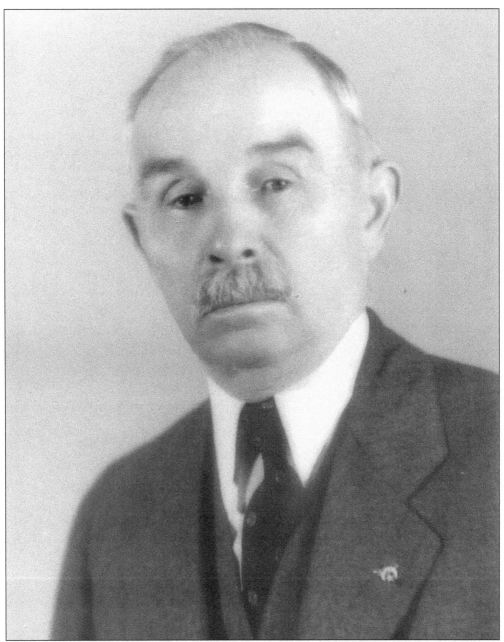

Thomas Edward Mitchell (1864–1934) came to the Tequesquite Valley—in what was to become Harding County—in 1881. He went to work as a cowboy at age 16, and was a wagon boss for the Huerfano Butte Cattle Company in Colorado before becoming manager for the Bar T Cross Ranch in New Mexico. T.E. Mitchell eventually purchased the Bar T Cross Ranch and, with additional land purchases, established the Tequesquite Ranch in the late 1890s. In the 1920s, Mitchell was elected to the state senate and was instrumental in the creation of Harding County. He was also a founder of the New Mexico Cattle Grower's Association, and was president of the association from 1920 to 1922. (Tequesquite Ranch.)

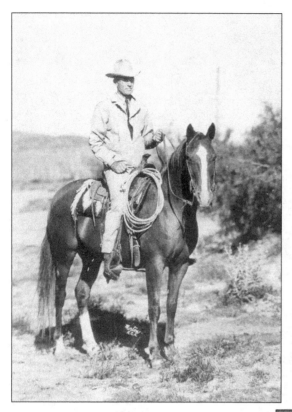

Albert Knell "A.K." Mitchell (1894–1980) was born in Clayton, New Mexico, and grew up on the Tequesquite Ranch. He earned a degree in animal husbandry from Cornell University in 1917, and after service in World War I, returned to the Tequesquite Ranch to work with T.E. Mitchell. A.K. became the general manager of the Bell Ranch in 1933, and managed both the Bell Ranch and the Tequesquite Ranch until 1947, when the Bell Ranch was liquidated. (Tequesquite Ranch.)

Albert Julian "Al" Mitchell (1934–1986) was born in Raton, New Mexico. Like his father, A.K. Mitchell, Al earned a degree in animal husbandry from Cornell University in 1955. While at Cornell, he was captain of the polo team. He returned to the Tequesquite Ranch in 1958 to work with his father. Al was active in the New Mexico Cattle Grower's Association, and served as its president from 1976 to 1978. (Tequesquite Ranch.)

Three

"I See by Your Outfit"

Contrary to common opinion, cowboys did not wear blue jeans in the earliest days of the cattle industry. Those iconic pants were not manufactured by Levi Strauss & Co. until 1873, and although they were comfortable and durable, they were also expensive. As a result, most cowboys wore pants made of wool, either Civil War surplus or purchased in secondhand stores. They also wore flat-heeled boots designed for soldiers to wear while marching. If he could save enough money, a cowboy could eventually purchase a pair of custom-made boots with round toes for slipping easily into a stirrup and high heels to prevent the foot from slipping through the stirrup and hanging up the wearer.

Often, a cowboy would wear chaparejos, or chaps, leather leggings designed to protect the legs from heavy brush or thorns while riding. Chaps could be shotgun style, worn like a second pair of pants, or batwing. The advantage of batwing chaps was that they could be put on without removing the boots.

Cowboys wore bandanas or neckerchiefs for many reasons. The bright colors made a cowboy more visible in a storm. The bandana could be used to keep dust out of the mouth and nose, to prevent sunburn, to wipe sweat away, to keep ears warm in winter, or to tie a hat on the head in a windstorm. It could also be used as a bandage, a tourniquet for more serious wounds, or as a blindfold for a horse.

Similarly, the cowboy's hat shielded the eyes from the sun, kept the head cool, or could be used as a bucket for drawing water. It could also be used to smack a horse's head or rump to get its attention. Southwestern cowboys generally favored hats with tall crowns and wide brims. On northern ranches, cowboys wore hats with narrow brims and low crowns.

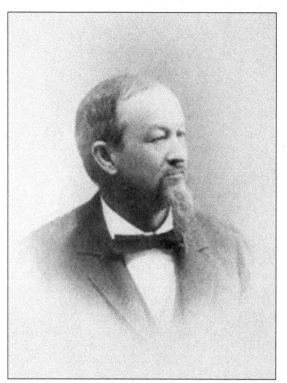

Samuel Caldwell Gallup (1837–1904) was born in Norwalk, Ohio, and became a saddlemaker's apprentice with the Gallatin Saddlery Company of Denver, Colorado, in 1864. In 1869, he opened his own saddlery in Pueblo, Colorado. He quickly became a leading provider of top-quality saddles and other equipment for working cowboys. S.C. Gallup died of heart failure in 1904. (Author's collection.)

S.C. Gallup's children, daughter Judith and sons Hallett and Boone, were operating the saddlery company when this 1909 company catalog was published. The company sold saddles, chaparejos, bits, bridles, spurs, and other equipment every cowboy needed. The S.C. Gallup Saddlery Company continued to make western stock saddles until the 1930s. (Los Lunas Museum of Heritage and Arts.)

Established 1870 Incorporated 1898

ILLUSTRATED CATALOG
AND NET PRICES

No. 22

of

The S. C. Gallup
Saddlery Co.

The Sign of *That Makes*
"Quality" *"Good"*

Since 1870—MANUFACTURERS—*Still At It*

of

Saddles, Chaparejos, Bridles, Scabbards, Cartridge
Belts, Cuffs, Spur Straps, Cinchas, Harness
and Strap Work of Latest Designs

111-113 West Fourth Street, Pueblo, Colorado, U. S. A.

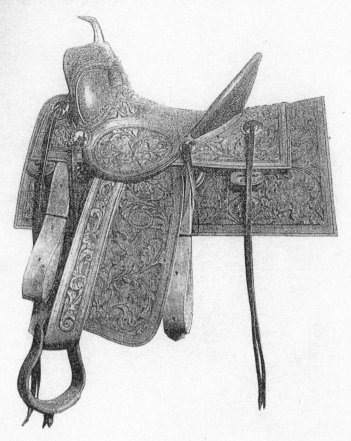

No. 2202 SADDLE $125.00

TREE No. 103 Visalia	FENDERS Heavy, 10x20 inches
SEAT 12 to 16 inches	STIRRUP LEATHERS 3¼ inches
HORN No. 7 Sterling	LONG LATIGOS 2 inches
FORK 15-inch Swell	SHORT LATIGOS 2¼ inches
CANTLE 5½ inches	STIRRUPS Nos. 20FS or 39LT
RIGGING Solid, Double	CINCHAS Nos. 3014 and 600
SKIRTS 31x16½ inches	WEIGHT 40 lbs. complete

REMARKS—No. 2202 Saddle is a beautiful full flower hand carved saddle, exceptionally well proportioned in all of the seat sizes specified and is occasionally ordered with Solid Silver or German Silver skirt and jockey corners or other ornaments as illustrated on the ornament page. We will be pleased to quote you on any specifications as to additional ornaments, special combination of tree as shown on tree pages or any other personal ideas along the line of construction. We know how to make them to your satisfaction. Write for a quotation on your special order.

The most important part of a saddle is the tree, the rawhide-covered wooden frame that determines the length and width of the finished saddle. The tree provides the frame upon which all other parts of the saddle are attached. Equally important are the seat, which supports the rider, and the saddle rigging, consisting of front girth cinch and flank cinch. (Los Lunas Museum of Heritage and Arts.)

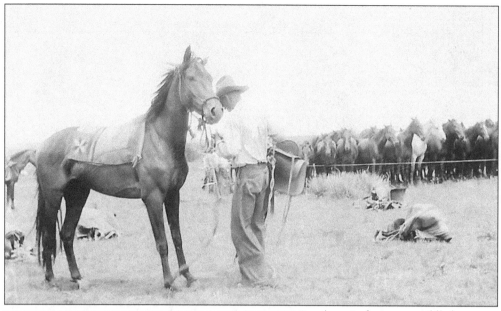

A typical western saddle has no padding, either between the saddle and the rider or between the saddle and the horse. A blanket or pad is used to provide comfort and a good fit for the horse's back. Pictured here is a Bell Ranch cowboy, saddling his horse in 1927. (New Mexico Farm and Ranch Heritage Museum.)

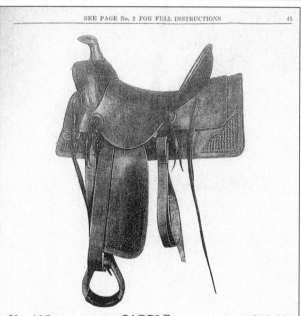

SEE PAGE No. 2 FOR FULL INSTRUCTIONS 45

No. 105 SADDLE $35.00

TREE No. 38 Minnequa	FENDERS Medium, 7x16 inches
SEAT 12 to 15 inches	STIRRUP LEATHERS 2 inches
HORN No. 11 Steel, Covered	LONG LATIGOS 1½ inches
FORK 9-inch Swell	SHORT LATIGOS 1½ inches
CANTLE 4½ inches	STIRRUPS Nos. 910P or 100P
RIGGING Double, Connected	CINCHAS Nos. 20 Cotton, Connected
SKIRTS 26x13 inches	WEIGHT 20 lbs. complete

REMARKS—No. 105 Saddle is the running mate to No. 100, described on the previous page, but we save you five dollars by using a hide covered tree with only a nine-inch swell and the dimensions of the skirts and strap work made a little smaller as you will note by comparison of descriptions. The cinch rings on both saddles are russet enameled steel, strongly connected; the latigos are dependable. The cantle is medium height with sloping cantle, making a comfortable seat. Solid stamped corners, front, and in seat.

Representing the lower end of the range of saddles offered by the S.C. Gallup Saddlery Company, this western stock saddle could be purchased for $35 in 1909 (the equivalent of almost $1,000 today). For a working cowboy of that era, however, that was still a serious investment. Although most cowboys did not own their own horses, they did own their own saddles. (Los Lunas Museum of Heritage and Arts.)

This young fellow is likely a real cowboy, although the carrying of sidearms was not that common, especially after the open-range era. In fact, Manly Chase prohibited his cowboys from carrying guns while working for his Chase Ranch. This cowboy is wearing shotgun chaps. The tobacco pouch in his pocket indicates that this cowboy hand-rolled the cigarette in his mouth. (Collection of Bill Hill.)

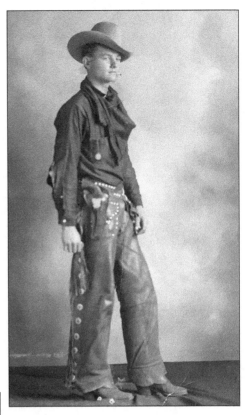

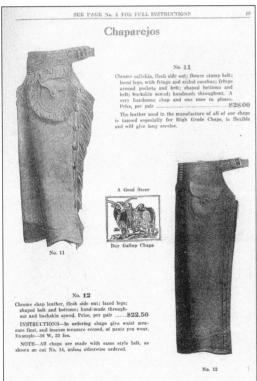

Chaparejos, or chaps, are leggings designed to fit over a cowboy's trousers to provide protection from thorny brushes and, to a lesser degree, warmth during cold weather. Chaps can be shotgun, like those pictured here; batwing, a style favored by Bell Ranch Cowboys; or woolys, which was the style favored by cowboys in colder areas like northern Colorado, Wyoming, and Montana. (Los Lunas Museum of Heritage and Arts.)

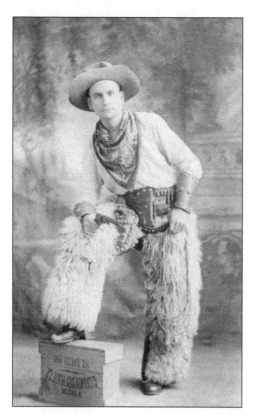

It is not known whether this fellow is a real cowboy or not. But the presence of wooly chaps and the awkwardly worn revolvers would argue against it. Many photographic studios in the West kept just such props for patrons who wanted to "play cowboy." (Collection of Bill Hill.)

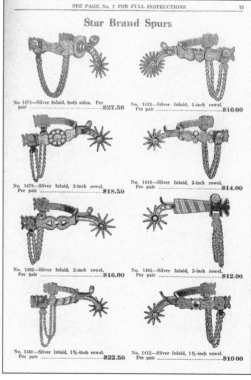

Spurs were worn by cowboys as an additional means (along with legs and hands) of controlling a horse. Most of these spurs have rather severe two-inch rowels. The chains are designed to fit under the sole of the boot, in front of the heel. Buttons are provided on the spur to attach leather straps that buckled over the boot. (Los Lunas Museum of Heritage and Arts.)

These cowboys are striking a
common pose called "the poker
draw," referring to both casual
gunplay and a popular card game.
This photograph was taken by Joseph
E. Smith in his studio in Socorro,
New Mexico, around 1890. Note the
fancy, large rowel spurs worn by the
cowboy on the left. (Suzanne Smith,
the Joseph E. Smith Collection.)

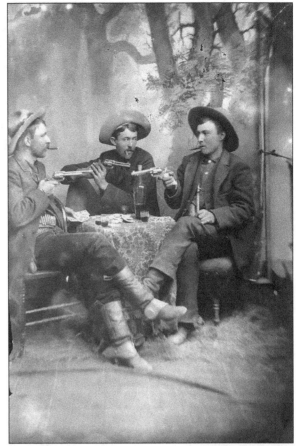

This is another version of "the poker
draw" pose. These cowboys are from
Nara Visa, a cattle-shipping point
located on the Canadian River,
northeast of Tucumcari. It is possible
that these cowboys worked for the
Bell Ranch, in nearby San Miguel
County. (Michael Jaramillo.)

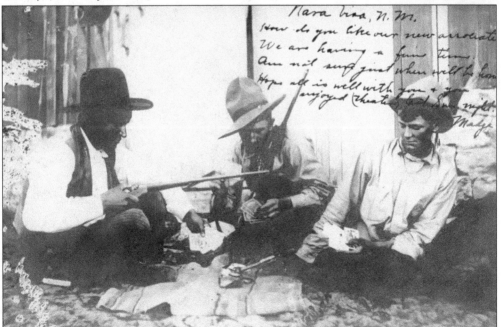

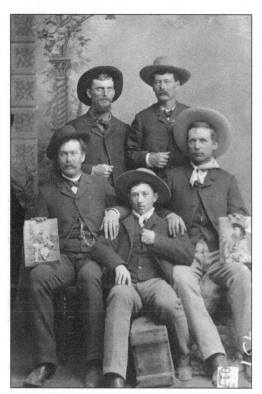

It was not uncommon for cowboys to include photographs in their studio portraits. Photographs of parents, sweethearts or other admired individuals were held by the subjects. The man on the right in this photograph by Joseph E. Smith is holding a photograph of Capt. Jack Crawford, a renowned frontier scout and Wild West show proprietor. (Suzanne Smith, the Joseph E. Smith Collection.)

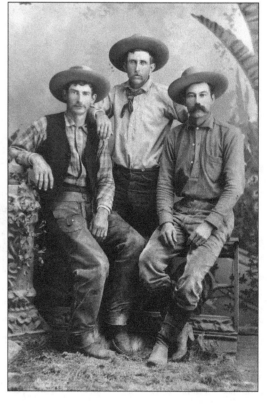

Photographer Joseph E. Smith made this portrait of three young cowboys at his studio in Socorro, New Mexico, around 1890. The cowboy on the left is wearing shotgun chaps. All three of these cowboys are wearing a similar style of hat. (Suzanne Smith, the Joseph E. Smith Collection.)

The romantic image of the cowboy bore little resemblance to reality. These two buckaroos, reflecting the theme of Johnny Mercer's "I'm an Old Cowhand (From the Rio Grande)," likely never punched a cow—'cause they didn't know how. On the left is Bob Hunt (1906–1964) of Pasadena, California. On the right is Santa Fe poet Witter Bynner (1881–1968), who was famous for his afternoon "teas" during Prohibition. Bynner obtained the moonshine for his tea parties from a nearby Indian pueblo. (Collection of Bill Hill.)

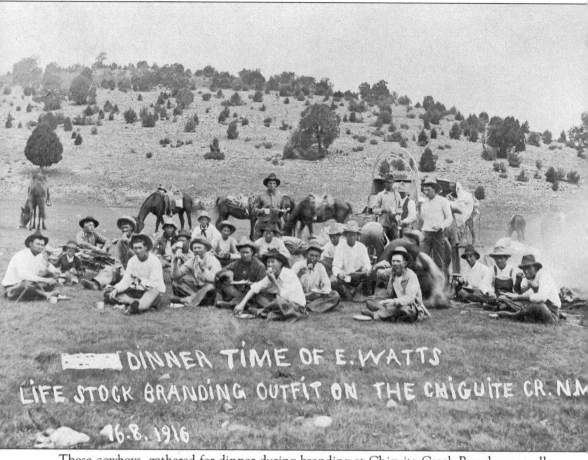

DINNER TIME OF E. WATTS
LIFE STOCK BRANDING OUTFIT ON THE CHIGUITE CR. N.M
16.8. 1916

These cowboys, gathered for dinner during branding at Chiguite Creek Ranch, generally have similar styles of hats, shirts, and trousers. A keen observer could tell which part of the country a cowboy worked in by his dress. (New Mexico State University Library, Archives and Special Collections.)

Four

THE HISTORIC RANCHES
OF MORA COUNTY

Some of the earliest inhabitants of Mora County, New Mexico, were Jicarilla Apaches. Early agriculture in Mora County consisted of wheat farming to provide flour for nearby Fort Union. The fort had been established to provide protection for travelers on the Santa Fe Trail, which crossed the eastern portion of the county. With four thriving flour mills in the county, Mora County was called "the Breadbasket of New Mexico." Cattle ranching was not as extensive as field crop farming, but there were significant cattle operations in the county. Mora County was established as a New Mexico county in 1860, with the town of Mora designated as the county seat.

One of the Spanish land grants in Mora County was the John Scolly Grant, given to John Scolly and others in 1843. The grant was located at the confluence of the Mora and Sapello Rivers, at a place called La Junta (the junction). In 1849, Samuel Watrous bought a half interest in the 50,000-acre grant. He built a 20-room hacienda that also included space for a mercantile store. All of the materials for the house had to be hauled over the Santa Fe Trail. The ranch house is still standing and has been carefully restored. Samuel Watrous grazed over 1,000 head of cattle and horses on his Watrous Valley Ranch.

Just west of Watrous Valley Ranch was the ranch of Samuel Watrous's son-in-law William Kronig, who had married Watrous's daughter Louisa. Kronig bought Scolly Grant land from Alexander Barclay and established the Phoenix Ranch.

Elliott "Chope" Phillips, son of Colfax County ranch owner Waite Phillips, purchased the Watrous Valley Ranch in 1949 and later formed the Phillips Ranch, a short distance down the Mora River.

Samuel Watrous (1809–1886) was a merchant selling to miners in Southern Colorado and the Ortiz Mountains in New Mexico, when he decided to enter the ranching business. He purchased land at the junction of the Mora and Sapello Rivers, an area named La Junta. This valley was where the two branches of the Santa Fe Trail, the Mountain Path and the Cimarron Path, merged. (Brian and Nicole King.)

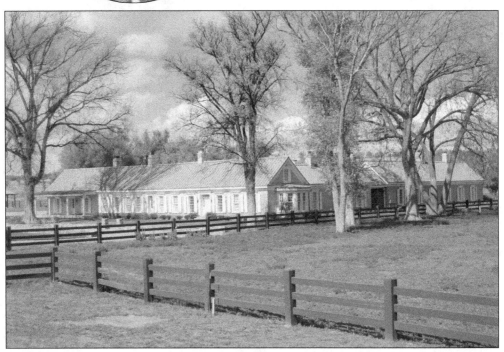

In 1849, Samuel Watrous began construction of a large ranch house, consisting of 20 rooms around a central patio. One end of the building served as a store, and there were two additional storerooms, each twice as large as the main house. The house has undergone several restorations over the years. Ultimately, Watrous grazed several thousand head of cattle on his ranch. (Author's collection.)

Samuel Watrous, pictured here with his third wife, Josephine, committed suicide in 1886 by shooting himself in the head, twice. Several factors may have contributed to his decision to end his life. His son Samuel Watrous Jr. had himself committed suicide a few years before, and the elder Watrous may have been despondent over that event. An unusually harsh winter in 1884 took a toll on his cattle herd, and he was in debt to both the Charles Ifeld Company and the First National Bank of Las Vegas. On the other hand, some have speculated that Josephine conspired with Samuel's son Joseph to cause Samuel's death. (Brian and Nicole King.)

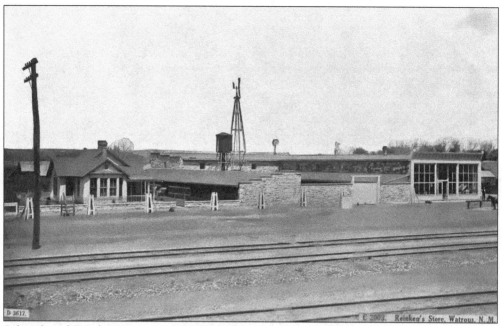

Schmidt and Reinken's store, pictured on the right in this c. 1916 photograph, was located near the railroad tracks, making it convenient to both ship and receive goods for the mercantile. (New Mexico State University Library, Archives and Special Collections.)

A.O. Hadley purchased the Clyde Ranch in 1888 from the descendants of William B. Tipton, who founded the ranch in 1849. Pictured here is Hazel Hallett, daughter of A.O. Hadley's son-in-law William Hallett, in front of the barn at Clyde Ranch. Hazel later married Ashley Pond Jr., owner of three ranches in nearby Shoemaker Canyon. (Peggy Pond Church estate.)

This pole, pictured here on the Clyde Ranch, will be used to construct the apparatus for the haying operation. It is being moved into position by a team of draft horses and two-wheel wagons supporting the pole. The Clyde Ranch was named for the Clydesdale draft horses raised on the ranch. (Peggy Pond Church estate.)

In this photograph, the pole has been raised into position, and a yardarm and rigging have been installed. This mechanism allowed for the transport of hay from the hay wagon to the haystack. This arrangement made it easy for a small crew of five men to efficiently stack the hay. (Peggy Pond Church estate.)

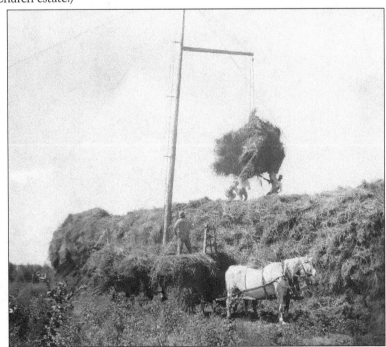

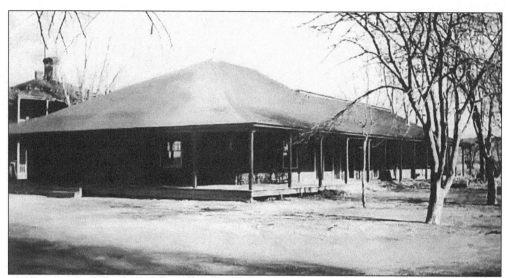

Ashley Pond Jr., who founded the Los Alamos Ranch School, later the site of the Manhattan Project to develop the atomic bomb, initially wanted to establish his school in Shoemaker Canyon. He erected this building in 1904, but it was destroyed by a flood shortly after it was completed. Pond, his wife, Hazel, and their daughter, Peggy, barely escaped the floodwaters. (Los Alamos Historical Museum Archives.)

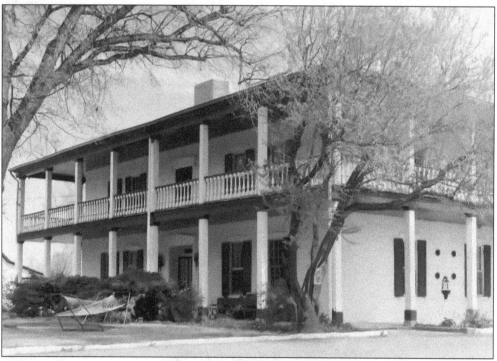

This is the ranch house on the Phoenix Ranch, established by William Kronig (1827–1900) in 1856. Kronig was the son-in-law of Samuel Watrous, having married his daughter Louisa. Phoenix Ranch was later purchased by R.G. Head (1847–1906), who was also a principal owner of the Prairie Cattle Company in Union County. (New Mexico State University Library, Archives and Special Collections.)

Chope Phillips, though spending most of the year at his family's home in Tulsa, Oklahoma, was happiest when he was at Philmont Ranch in Colfax County, New Mexico. He spent every summer there as a working cowboy. He is pictured here on a roundup at his father's Philmont Ranch. (Philmont Scout Ranch.)

Chope Phillips purchased the Watrous Valley Ranch in 1945, after service in World War II. Chope grew up spending summers on his father's Philmont Ranch, located near Cimarron, New Mexico. He purchased the southern portion of the Fort Union Ranch in 1959 and renamed that property Phillips Ranch. (Author's collection.)

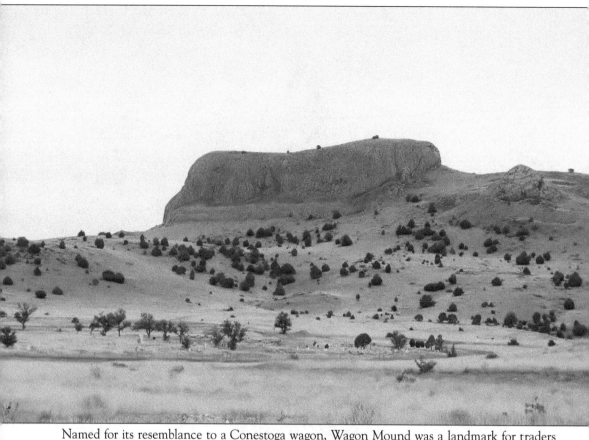

Named for its resemblance to a Conestoga wagon, Wagon Mound was a landmark for traders and travelers on the Santa Fe Trail. At the nearby village of Wagon Mound, in Mora County, travelers could cross from the Cimarron Cutoff to Fort Union, which was located on the mountain branch of the trail. The population of the village of Wagon Mound peaked around 1920 at 875 residents. (Author's collection.)

Five

THE HISTORIC RANCHES OF UNION COUNTY

The present Union County, New Mexico, was formed from portions of Colfax, Mora, and San Miguel Counties. The unwritten rule of thumb for siting county seats in New Mexico Territory was that the county seat should be no more than a day's horseback or wagon ride from any point in the county. Residents in the area that became Union County could be as far as 135 miles from the nearest county seat (Springer, Mora, or Las Vegas), involving several days' travel.

The first significant ranch in Union County was the Cross L, established in 1871, when brothers James, Nathan, and William Hall drove 2,500 longhorn cows and calves into the area from South Texas. They imported purebred Hereford bulls to improve the quality of their herds. In 1881, the Cross L Ranch was purchased by the Prairie Cattle Company. By 1882, the Prairie Cattle Company had acquired 100,000 head of cattle, grazing on 250 miles (north to south) of open range.

Blizzards in the late 1880s, combined with poor absentee management—and in spite of heroic efforts by legendary ranchmen like W.J. Todd in 1886 and Murdo Mackenzie in 1889—meant the ranch ceased to exist by 1918.

Other large Union County ranches included the Hundred-and-One Ranch in northeast Union County, the XIT Ranch in the southeast part of the county, and Stephen Wallace Dorsey's Palo Blanco Cattle Company. Another significant Union County ranch was the H-T Ranch, founded by B.W. Towner, which had sheep, cattle, and horses grazing on the open range.

Other notable ranches in Union County were George Baker's ranch; the Valley Ranch, owned by J.W. "Walt" Blackburn; the O.W. McCuistion ranch; the Pacheco Ranch near Quates; and Col. Jack Myers Potter's ranch on the Dry Cimarron River.

Things went well as long as beef prices were high and the grass was free, but those conditions did not last, as an influx of homesteaders, severe droughts, deadly winters, and the rise of the sheep industry brought an end to the practice of raising cattle on the open range.

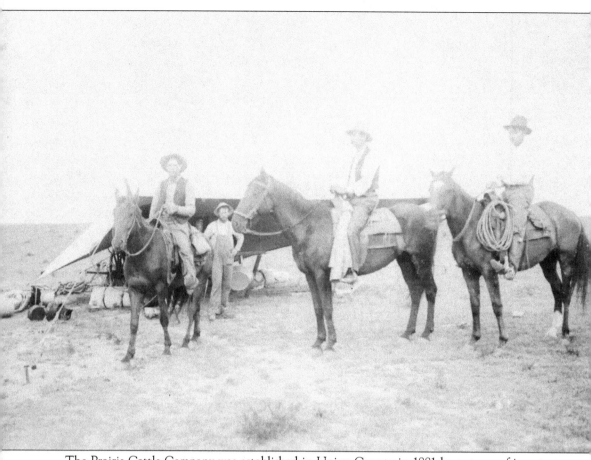

The Prairie Cattle Company was established in Union County in 1881 by a group of investors from Edinburgh, Scotland. By 1882, the company was grazing over 100,000 head of cattle. In all, there were more than 1,865,000 acres of grazing land in Union County. The cowboys pictured here worked for the Prairie Cattle Company. (Herzstein Memorial Museum.)

Robert Mansker (1861–1919), pictured here with his daughters Mary (left) and Helen (right), came to Union County in 1883. He was a rancher his whole life, working primarily for the Prairie Cattle Company. He married Inez McCollom, daughter of Clayton rancher F.H. McCollom, in 1894. Mary Mansker married Richard L. Sparks in 1916, and Helen Mansker married Wayne L. McVay in 1920. (Herzstein Memorial Museum.)

Between the years 1883 and 1886, the Prairie Cattle Company raised and shipped to market 54,000 head of cattle worth $1,300,000 (the equivalent of nearly $29,000,000 today). During the same four-year period, the ranch branded 83,000 calves. (New Mexico State University Library, Archives and Special Collections.)

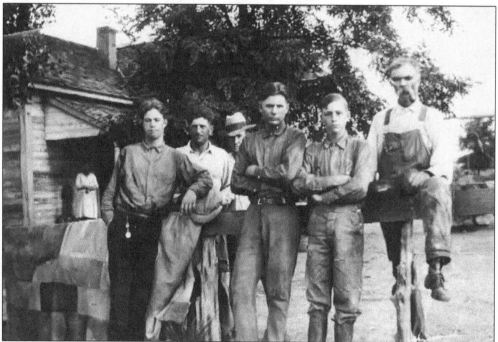

Pictured are, from left to right, Susie Beckner McCook (on the porch), Otis McCook, Carl Williams, Frank "Shorty" Iseman, Eugene McCook, C.H. "Hamp" McCook, and Hess McCook, some of the 23 people living at the McCook homestead in Union County during the Depression. The Depression and the terrible dust storms were devastating to Union County. Surprisingly, only about a fourth of the residents chose to leave. (Herzstein Memorial Museum.)

Jack Myers Potter (1864–1950), his wife, Cordelia, and their four children arrived in Clayton, New Mexico, in 1894. From 1894 to 1924, they raised cattle and feed crops on land acquired from filing claims and purchasing tracts from homesteaders who wanted to leave. Potter served two terms as state representative from Union County and was president of the Trail Driver's Association of the Southwest. (Herzstein Memorial Museum.)

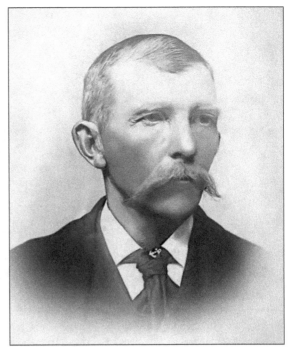

Robert C. Dow (1888–1969) was the son of Eddy County, New Mexico, sheriff Les Dow. He was elected as New Mexico's attorney general in 1926. He survived a knife attack by F.L McCauley, in Clovis, New Mexico, in 1917. In addition to his friendship with rancher Col. Jack Potter from Clayton, Dow was also a friend of Tom Mix, the famous Western silent film star. (Herzstein Memorial Museum.)

Forest Atchley (1909–1999), seated right, and Ruby Smith, seated left, were married in 1934. That year, Forest and his partner Stuart MacArthur began building a ranch at Sofia, New Mexico, eventually acquiring several thousand acres of rangeland. He served three times in the New Mexico State Legislature and ran for both the US Senate and House of Representatives. (Herzstein Memorial Museum.)

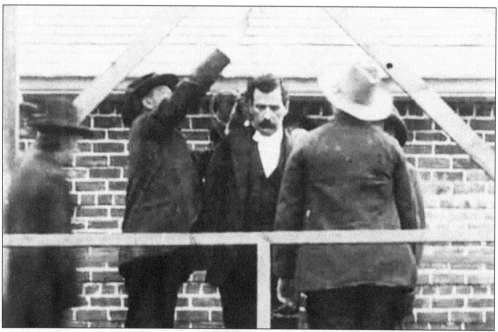

Thomas Edward "Black Jack" Ketchum (1863–1901) was the first (and only) person hanged in the history of Clayton, New Mexico. W.H. Reno is shown here adjusting the noose. Reno was a Colorado & Southern Railroad detective who had pursued Ketchum and his brother Sam for train robbery. An enclosure was built around the scaffold, and people bought tickets to view the hanging. (Gordon Hall.)

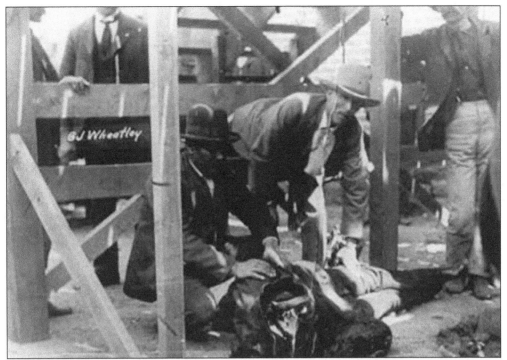

Careful calculations were made to determine the length of the hanging rope, based on the height and weight of the person being executed. In Black Jack Ketchum's case, however, between the time the calculation was made and the actual execution, he gained considerable weight. When the trap was sprung, Ketchum fell with such force that he was decapitated. (Gordon Hall.)

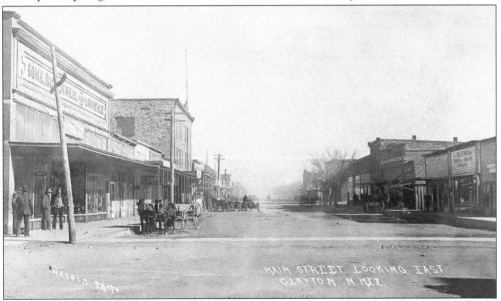

When the railroad arrived in Clayton in 1888, the town consisted of a tent town, three saloons, a livery stable, two small hotels, and a general store. This photograph was taken sometime around 1906. The Eklund Hotel is the two-story, stone building in the center left of this picture. (New Mexico State University Library, Archives and Special Collections.)

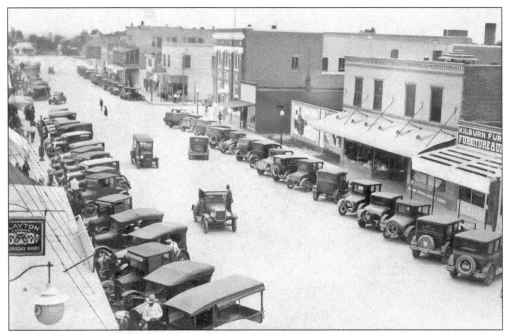

By the time this photograph was taken, the town had grown considerably. The photograph was taken sometime after 1928, when the downtown streets were first paved. The Eklund Hotel can be seen at the end of the street, top center. (New Mexico State University Library, Archives and Special Collections.)

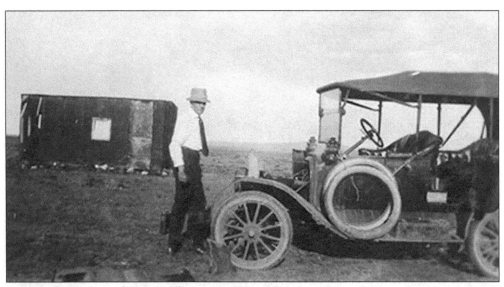

In 1916, Orren Beaty (1883–2005) came to Union County to serve as county extension agent. He bought a section of land and began stocking it with cattle. In 1921, he was elected to the state legislature from Union County. He worked with state senator T.E. Mitchell, of the Tequesquite Ranch, to establish Harding County from portions of Union and San Miguel Counties. (Author's collection.)

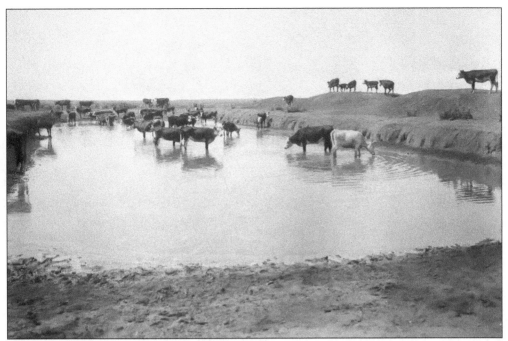

During the open-range era, natural water holes like this one, called stock tanks, were how cattle got water. Often, a rancher would purchase a small portion of land containing a natural water source and then lease, or just "use," as much rangeland adjacent to the tank as needed for the cattle to graze. (New Mexico State University Library, Archives and Special Collections.)

The end of the open-range era and the arrival of barbed wire caused many changes to ranching operations. Cattle could no longer travel freely to find fresh natural stock tanks. Ranchers had to dig wells and provide windmills to pump the water to the surface. Many large ranches kept a permanent crew whose only job was to maintain the wells and windmills on the ranch. (Author's collection.)

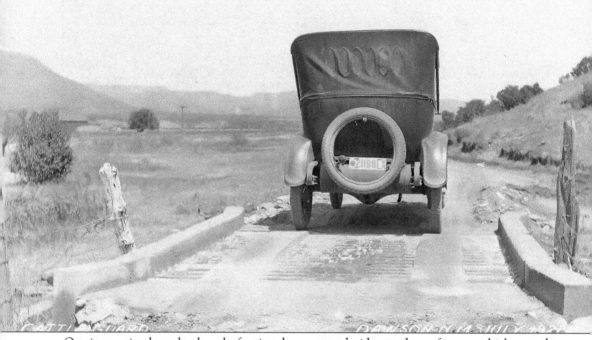

One innovation brought about by fencing the range and widespread use of motor vehicles was the cattle guard. A trench was dug across the entrance to a pasture, and a metal grate was installed over the opening. The bars of the grate were spaced far enough apart that cattle and horses could not cross it. This cattle guard, photographed in 1922, was near the town of Dawson, in Colfax County. Union County was once part of Colfax County. (New Mexico State University Library, Archives and Special Collections.)

Six

THE HISTORIC RANCHES
OF SAN MIGUEL COUNTY

San Miguel County, New Mexico, was created in 1852 when the United States acquired the territory of New Mexico from Mexico. San Miguel was one of the original nine counties created by the New Mexico territorial legislature. The original county seat was San Miguel del Bado, but in 1864, it was moved to Las Vegas.

The premier historic ranch in San Miguel County is unquestionably the Bell Ranch, consisting originally of more than 650,000 acres acquired from the land grants of Don Pablo Montoya. The ranch was purchased from Juan Pablo Montoya by Englishman Wilson Waddingham in 1875. Bell Ranch headquarters is located about 30 miles north of Tucumcari, New Mexico. The Bell Ranch was the largest single, undivided ranch in New Mexico until 1947, when it was reorganized. At that time, the Bell Ranch brand, ranch name, Bell Ranch headquarters, and 130,000 acres of range were retained near the center of the Montoya grant. The remainder of the ranch was divided into five other parcels and sold.

The main portion of the Bell Ranch was purchased in 1970 by William N. Lane II, of Chicago, Illinois. He acquired additional adjoining rangeland and brought the ranch up to nearly 300,000 acres. Bill Lane was killed in a car accident on the ranch in 1978. The ranch was then owned by a trust for the Lane children until 2010, when John Malone, who also owned the TO Ranch in Colfax County, purchased the Bell Ranch. The ranch as presently configured can support up to 5,000 cow-calf units. The Bell Ranch, even today, is so large that it has its own zip code, 88441.

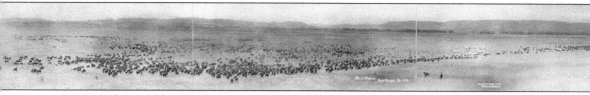

In 1914, photographer P. Clinton Bortell took this panoramic photograph of the Bell Ranch. (Library of Congress.)

Wilson Waddingham (1833–1899) was a Canadian-born entrepreneur and land speculator who purchased most of the Pablo Montoya Grant in San Miguel County in 1871 and 1872 and began stocking the range with cattle. He was the first to register the Bell Ranch brand. His ranching efforts eventually failed, however, due to his habit of overreaching and the collapse of the cattle market in the late 1880s. (Author's collection.)

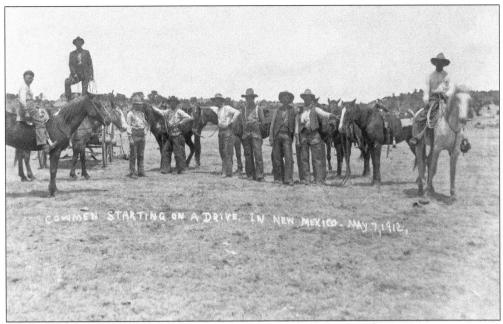

This photograph, taken in 1912, shows Bell Ranch cowboys ready to start the spring roundup. Cows and calves would be gathered from the winter range and brought to a central location to be branded. During open-range days, cattle from several ranches would be rounded up. Once calves had "mothered up," they would be marked with the mother's brand. (New Mexico State University Library, Archives and Special Collections.)

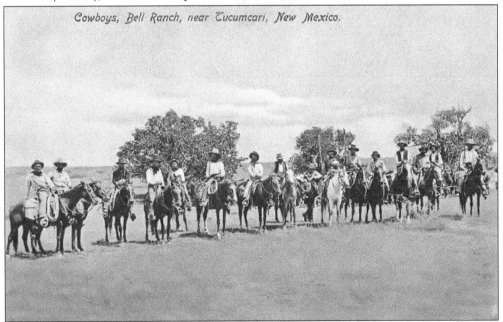

These Bell Ranch cowboys gathered for this group portrait around 1910. Although this postcard indicates the ranch is located "near" Tucumcari, New Mexico, which is in Quay County, the majority of the ranch's acres are actually in San Miguel County. (New Mexico State University Library, Archives and Special Collections.)

97

Arthur J. Tisdall (1856–1898) was born in Ireland and became general manager of the nearly bankrupt Bell Ranch in 1893. Jack Culley worked for Tisdall, starting in 1894, as a cowboy at the Bell. During his tenure as ranch manager, Tisdall restocked the depleted cattle herd, acquired top-quality Hereford bulls, and put the ranch back on a paying basis. (Author's collection.)

Commercial hunting made the American bison nearly extinct by the 1880s. A few buffalo herds were maintained at some of the larger ranches in the West. In New Mexico, the Philmont Ranch and the Bell Ranch had buffalo herds. Pictured here in this S.A. Morton photograph is the Bell Ranch buffalo herd. (New Mexico Farm and Ranch Heritage Museum.)

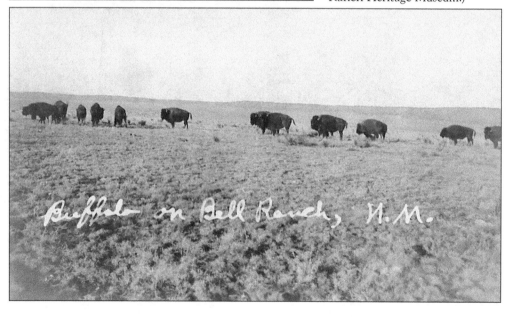

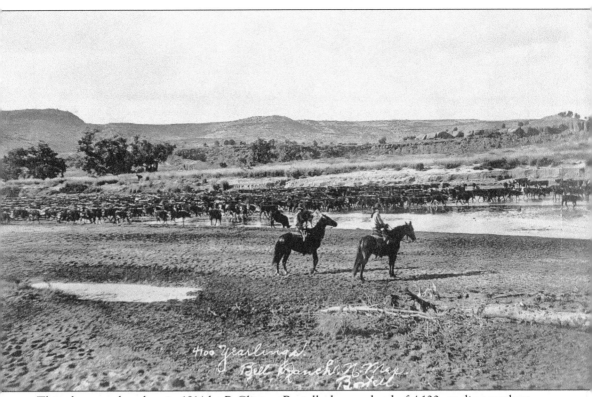

This photograph, taken in 1914 by P. Clinton Bortell, shows a herd of 4,100 yearling cattle at the Bell Ranch. By this time, the Bell had become primarily a cow-calf operation. While C.M. O'Donell was the manager of the Bell Ranch, the cattle herd was improved with the use of top-quality purebred bulls and selective breeding. (New Mexico State University Library, Archives and Special Collections.)

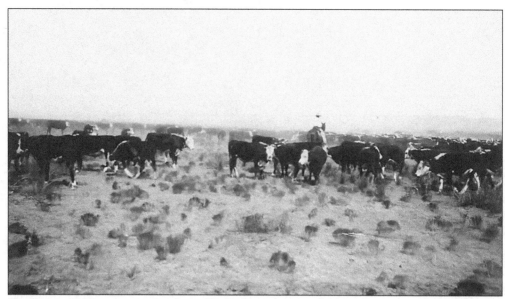

By the late 1800s, overgrazing, the collapse of market prices, drought, and severe winters had forced most of the ranchers in northeastern New Mexico out of business. A new group of range managers entered the business and introduced fenced pastures, windmills, supplemental feeding, and selective breeding. (New Mexico Farm and Ranch Heritage Museum.)

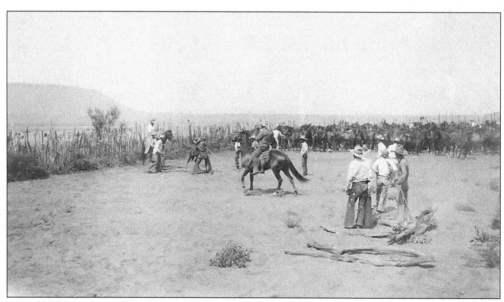

These Bell Ranch cowboys are branding colts in this 1930s photograph, taken by an unidentified photographer. (New Mexico Farm and Ranch Heritage Museum.)

John H. "Jack" Culley (1864–1954), was an Englishman whose family had a long history of livestock breeding. He came to New Mexico in 1888 and worked for ranches in the Wagon Mound area. From 1894 to 1897, he was range boss at the Bell Ranch under general manager Arthur Tisdall. Culley relates his experience at the Bell Ranch in *Cattle Horses and Men*, published in 1940. (Author's collection.)

The famous Bell Ranch chuck wagon, loaded with cowboy bedrolls, is shown crossing the Canadian River on the ranch in this c. 1929 photograph by S.A. Morton. This chuck wagon is now on display at the New Mexico Farm and Ranch Heritage Museum in Las Cruces. (New Mexico Farm and Ranch Heritage Museum.)

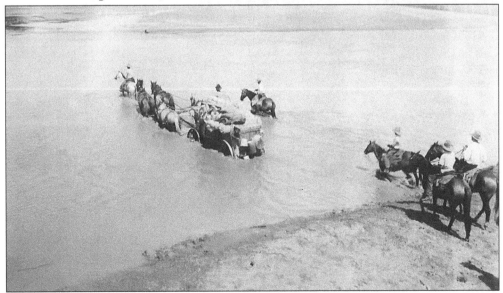

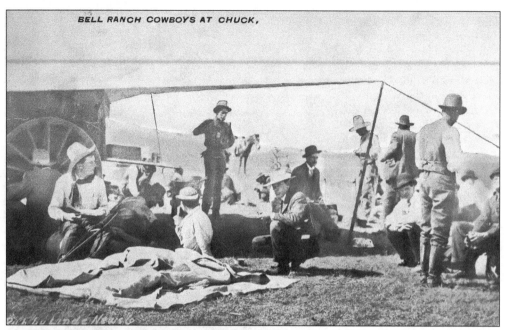

BELL RANCH COWBOYS AT CHUCK,

The famous Bell Ranch chuck wagon can be seen in this c. 1910 photograph. This was probably a special occasion, due to the presence of women and some "suits." (Collection of Bill Hill.)

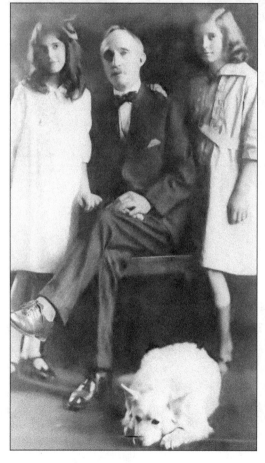

Following the death of Arthur Tisdal in 1898, Charles M. O'Donel (1860–1933) became the Bell Ranch general manager. He held the position for almost 30 years. He married for the second time in 1908 to Louise Harral; they had two daughters. Shown in this c. 1915 photograph, Betty (left) and Nuala (right) were raised on the Bell Ranch. (Author's collection.)

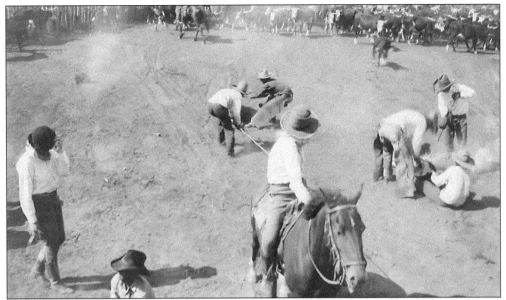

The O'Donel sisters were active participants in Bell Ranch activities. In this S.A. Morton photograph, taken around 1929, Betty, on horseback, has just heeled a calf and is dragging it to the branding fire. Her sister, Nuala, covering her face with her hat, is helping vaccinate the calves. (New Mexico Farm and Ranch Heritage Museum.)

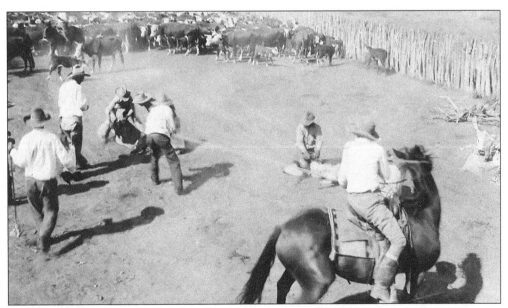

Betty O'Donel has heeled another calf and is holding it while a Bell Ranch cowboy approaches on the left with the branding iron. The photograph is by S.A. Morton. (New Mexico Farm and Ranch Heritage Museum.)

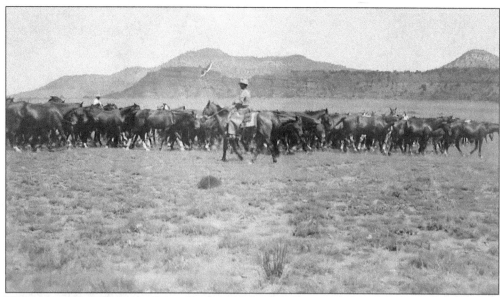

This is the remuda (from the Spanish word for "change of horses" or "remount") at the Bell Ranch in the 1920s. Jack Culley, range manager at the Bell Ranch in the 1890s, said that good cow horses were "adapted to the work they had to do," were "well formed, sturdy and well chested," and were "teachable" but had a tendency to "buck when rested." (New Mexico Farm and Ranch Heritage Museum.)

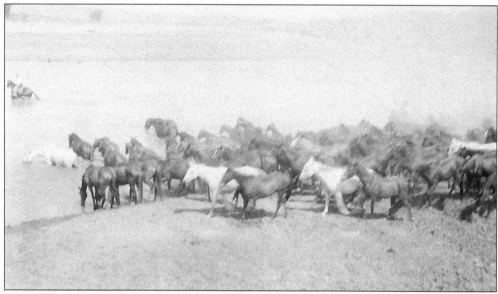

Horses can be driven or led to cross a body of water. The horses in this S.A. Morton photograph, taken in the 1920s, are being led. If a cowboy knows that he will be entering deep water with cattle or horses, he will be sure to be mounted on his best swimmer. (New Mexico Farm and Ranch Heritage Museum.)

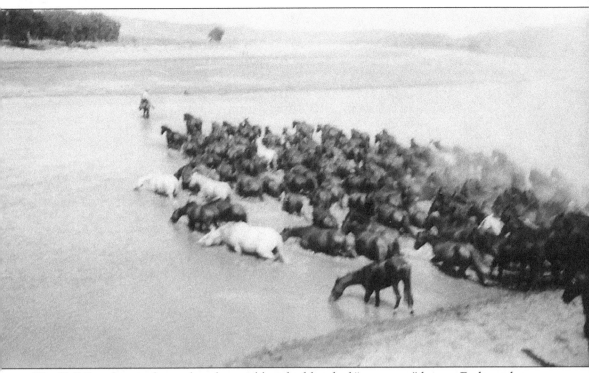

The Bell Ranch remuda numbered several hundred head of "cow-savvy" horses. Each cowboy would have several horses in his string, and they were selected for specific skills. Some horses were good for just gathering the cattle, or making a drive on them. Other horses were good at working cattle, cutting, or roping them for branding. Still others were good swimmers. (New Mexico Farm and Ranch Heritage Museum.)

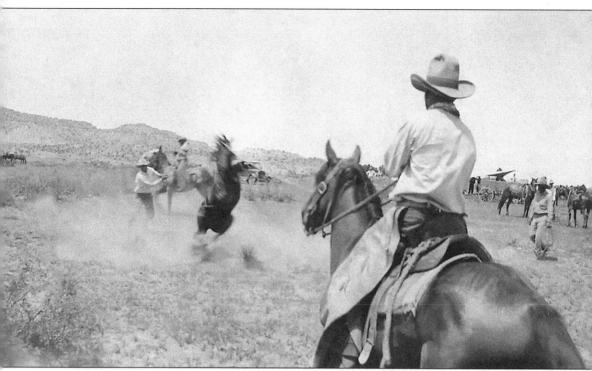

This horse refused to lead out from the rest of the remuda, so it had to be roped and pulled out by the cowboy on horseback, so it could be saddled. The presence of the Bell chuck wagon in the background suggests that this was during spring roundup. This photograph was taken by S.A. Morton around 1929. (New Mexico Farm and Ranch Heritage Museum.)

Albert K. Mitchell (1894–1980) was born in Clayton, New Mexico, and graduated from Cornell University in 1917 with a degree in animal husbandry. He became the general manager of the Bell Ranch in 1933. He had been running the Tequesquite Ranch in Harding County with his father, T.E. Mitchell, since 1917 and continued to run that ranch after he became manager of the Bell Ranch. (Author's collection.)

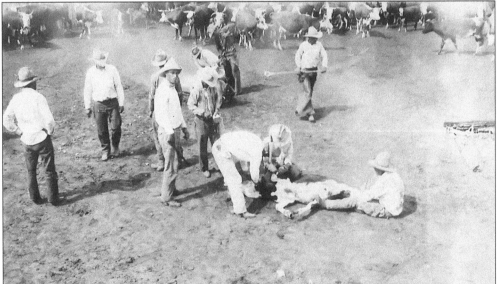

At the Bell Ranch, during fall works, calves are taken from their mothers, or weaned. The weaned calves are either sold right away or kept on the range until they are yearlings and sold in the spring or summer. (New Mexico Farm and Ranch Heritage Museum.)

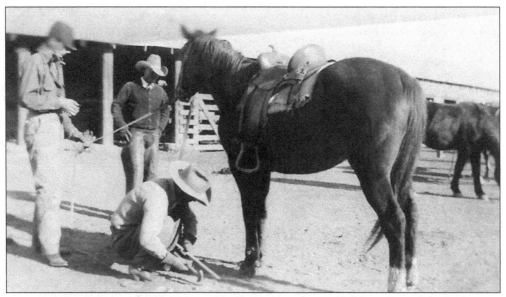

Bell Ranch cowboys had to know how to take care of their horses, especially looking after their feet. Here, a cowboy is checking out his handiwork after replacing a shoe on one of his horses. The cowboy in the middle of this photograph is Tod Moore. (New Mexico Farm and Ranch Heritage Museum.)

Tod Moore, a top Bell Ranch cowboy, is shown mounted on a Bell cow horse. He is wearing batwing chaps, popular with Bell Ranch cowboys of that era. The photograph was taken around 1929 by S.A. Morton. (New Mexico Farm and Ranch Heritage Museum.)

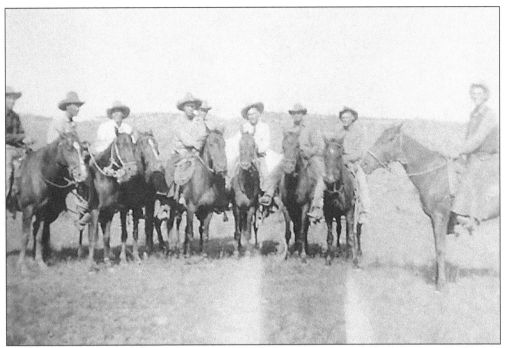

This crew of Bell Ranch cowboys was photographed by S.A. Morton in the late 1920s. In the days before the Bell range was fenced, roundups covered a lot of territory and required the cooperation of cowboys from several neighboring ranches. (New Mexico Farm and Ranch Heritage Museum.)

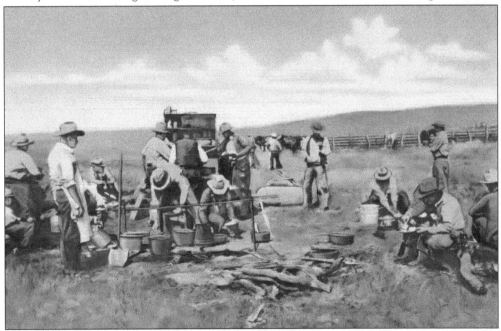

The chuck wagon was the center of a cowboy's life, serving as kitchen, bedroll storage place, and medical facility while the cowboys were on the trail during the open-range days. After the introduction of barbed wire to the range, the chuck wagon still served the same purposes during roundup and branding times. (Collection of Bill Hill.)

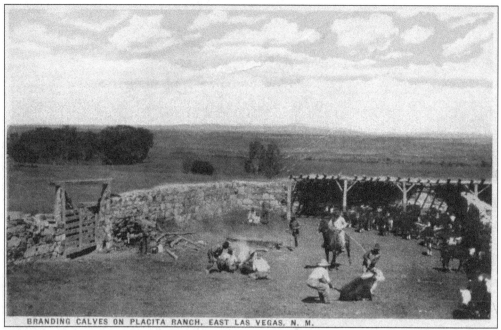

BRANDING CALVES ON PLACITA RANCH, EAST LAS VEGAS, N. M.

This postcard shows cowboys branding calves on the Placita Ranch, east of Las Vegas, New Mexico. While one calf is being branded on the left, the next calf is roped and tailed for its turn under the iron. (Collection of Bill Hill.)

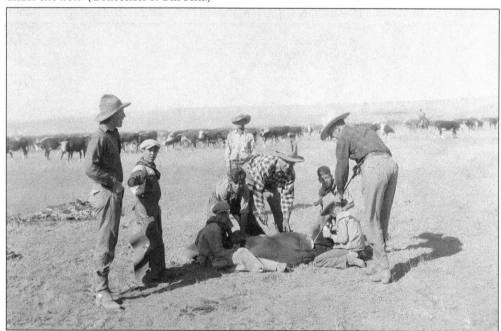

The 5,500-acre Forked Lightning Ranch, near Pecos in San Miguel County, was owned by John Van "Tex" Austin (1886–1938), who claimed to have been born and raised on a cattle ranch in Texas but who in fact grew up in St. Louis, Missouri. In this photograph, Tex, on the right, is branding a calf at Forked Lightning Ranch. (New Mexico State University Library, Archives and Special Collections.)

Seven

RODEOS AND OTHER AMUSEMENTS

Rodeos began as a way for cowboys to test their working skills against one another. They were initially informal affairs, involving cowboys from three or four nearby ranches. The first organized competitive rodeo was held in Cheyenne, Wyoming, in 1872. Prescott, Arizona, claims the first rodeo to charge admission and award trophies.

Competitive rodeo events are divided into two categories, timed events and rough stock events. In timed events, cowboys and cowgirls work against a clock while roping, barrel racing, steer wrestling, or goat tying. Roping events are calf roping, breakaway roping, and team roping. The contestant who completes the event in the shortest time is the winner. Rough stock events include bareback and saddle bronc riding and bull riding. In these events, cowboys must ride a horse or bull for a specified period of time (8 seconds). If the rider beats the clock, a score is given, with points awarded for both the rider and the animal.

Rodeos offered not only a chance for cowboys, and cowgirls, to test their skills, but also an opportunity to socialize and share the latest news and gossip.

The best of the rodeo cowboys and cowgirls had the opportunity to become professional performers, with active careers traveling from rodeo to rodeo, or in Wild West shows organized by such entrepreneurs as Buffalo Bill Cody, Capt. Jack Crawford, and Pawnee Bill.

Dances and other get-togethers were often held on specific holidays, particularly the Fourth of July. Christmas and Thanksgiving events were less common due to the difficulty of travel in the winter. It was more common, however, for ranch families living close to each other to visit more often.

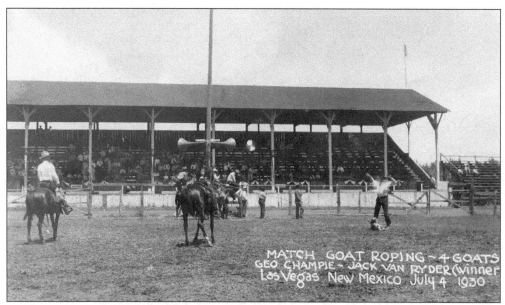

Cowboys often gathered at rodeos to match their skills against each other. Rodeo events echoed everyday cowboy chores. This postcard depicts George Champie (on the right, with arms raised) winning the goat roping contest at the Fourth of July Rodeo at Las Vegas, New Mexico, in 1930. The theory was that if someone could rope a goat, he could rope anything. (Collection of Bill Hill.)

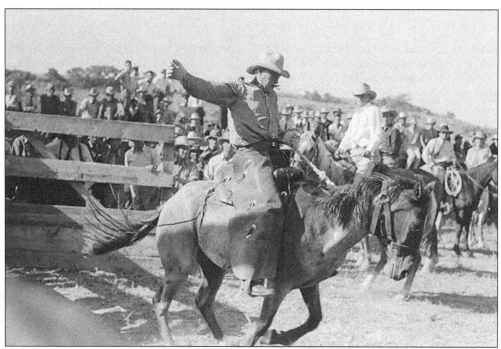

In saddle bronc riding events, cowboys use a bucking saddle that has the saddle horn removed. The cowboy stays connected to the horse with a heavy lead rope, called a bronc rein, attached to a halter. No bridle or bit is used in bronc riding. In bareback bronc riding events, the cowboy holds on with a rigging cinched tight around the horse's midsection. (Library of Congress.)

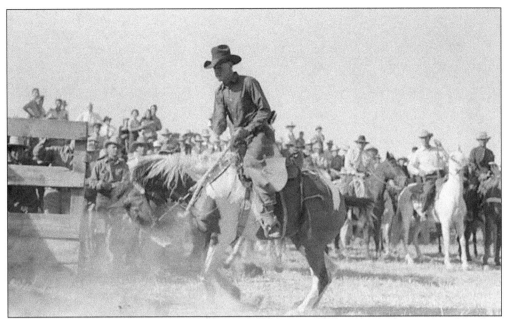

Rough stock events, like bronc riding, also employ well-trained horses and pickup riders (men or women) to assist riders who are bucked off and to help riders safely dismount at the end of a successful ride. One of the pickup riders can be seen on the white horse in the right background of this photograph. (Library of Congress.)

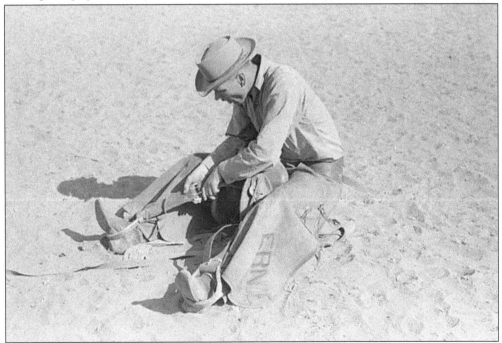

This cowboy is adjusting the stirrups of his saddle in preparation for the saddle bronc riding event at the Wagon Mound Bean Day Rodeo in 1939. He is wearing batwing chaps and a "stingy" brim hat. The photograph was taken by Farm Security Administration (FSA) photographer Russell Lee. (Library of Congress.)

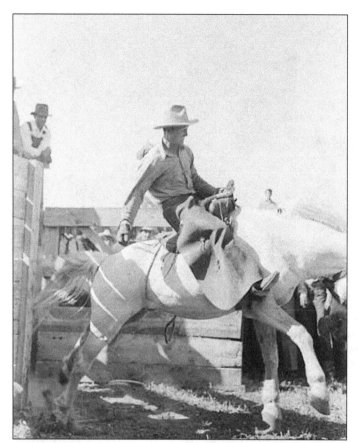

Rough stock events, such as saddle and bareback bronc riding, calf roping, and bull riding are timed events. In rough stock events, the rider must stay on the animal for a minimum of eight seconds. In roping events, the contestant with the shortest time is the winner. This saddle bronc rider is "marking" the bronc with his spurs as they come out of the chute. (Library of Congress.)

Cowboys wait their turns during a roping event at the Wagon Mound Bean Day Rodeo. The iconic Wagon Mound landmark can be seen in the background. The image was taken by FSA photographer Russell Lee in 1939. (Library of Congress.)

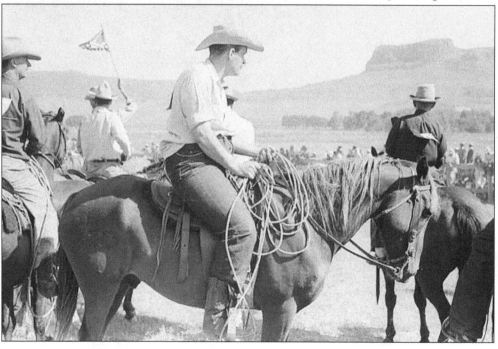

Horse races were popular events at local rodeos. This race is taking place at the Bean Day Rodeo, held at Wagon Mound, New Mexico, in 1939. Russell Lee took the photograph for the FSA. (Library of Congress.)

Rodeos are not just about competition. They are also about companionship and camaraderie. Rodeos are similar to spring and fall roundups, where cowboys from many neighboring outfits would gather at one ranch to help with rounding up, branding, and doctoring cattle. Pictured here are rodeo judges conversing between events. (Library of Congress.)

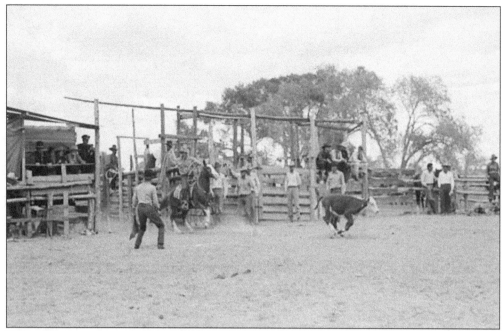

This calf has a pretty good jump on the cowboy trying to rope it. This calf roping event took place at the Wagon Mound Bean Day Rodeo in Wagon Mound, New Mexico, in 1939. The photograph was taken by Russell Lee, FSA photographer. (Library of Congress.)

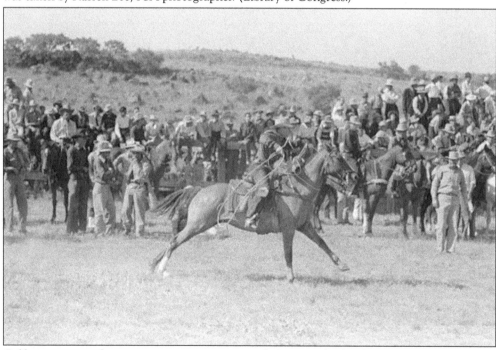

Calf roping, or tie-down roping, is a competitive rodeo event, which echoes ranch work in which calves, cows, and horses are roped for branding or medical treatment. The cowboy ropes a running calf from horseback, and then the horse stops and sets the rope. The cowboy runs down the rope to the calf, throws it to the ground, and ties three feet together. (Library of Congress.)

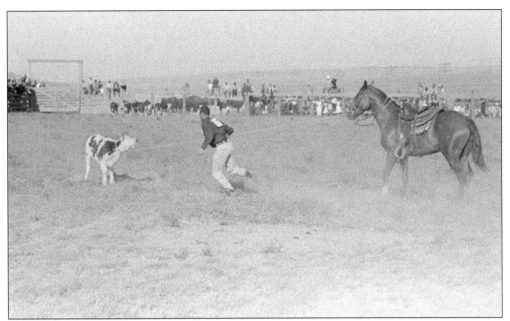

The horse's job is to hold the calf by keeping the rope taut while the cowboy dismounts and runs to the animal to throw it to the ground. A well-trained roping horse will back up slowly, insuring that the rope is kept tight while the cowboy ties three of the calf's legs together. This photograph was taken by Russell Lee in 1939. (Library of Congress.)

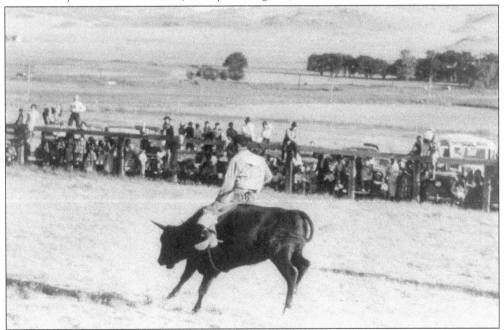

Steer riding was a popular rough stock event before the advent of professional bull riding. Steers were preferred at early rodeos because they were easier to handle and transport than bulls. It was not until 1935 that a rodeo featured bull riding, and it did not become a professional sport until the early 1990s. This photograph was taken by FSA photographer Russell Lee. (Library of Congress.)

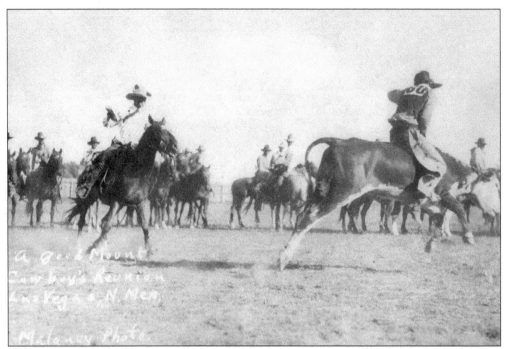

This photograph shows another steer being ridden, this one at the Cowboy's Reunion in Las Vegas, New Mexico, around 1925. The event judge, mounted on the horse on the left, is checking to see if the cowboy is spurring, or "marking," the steer properly. Another official is timing the ride. (New Mexico State University Library, Archives and Special Collections.)

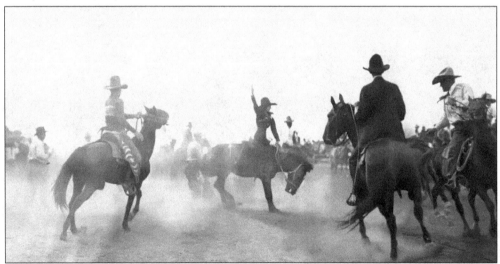

Tad Lucas (1902–1990) was born Barbara Inez Brown. She is shown here riding a bronc at a rodeo in Clayton, New Mexico, in the 1920s. She won the trick riding event at the Cheyenne, Wyoming, Frontier Days eight consecutive years in the 1920s, and she rode her last bucking horse in 1964 at the age of 62. Lucas was elected to the National Cowgirl Hall of Fame in 1978. (Herzstein Memorial Museum.)

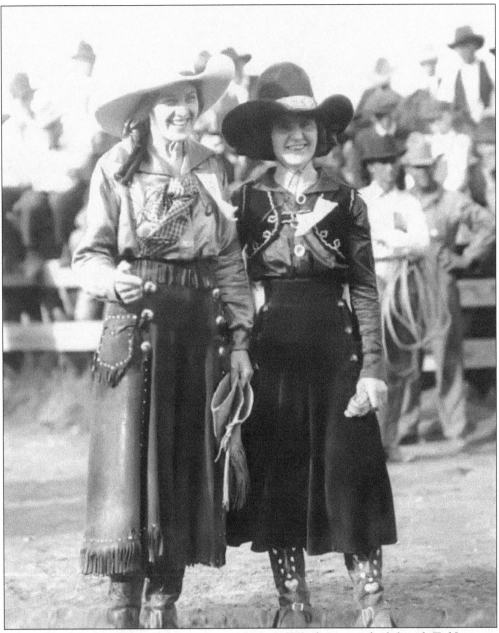

Prairie Rose Henderson, born Ann Robinson (1880–1933), shown on the left with Tad Lucas at a rodeo in Clayton, New Mexico, won the first horse race for women at the Cheyenne Frontier Days Rodeo in 1899. Her main rodeo event was bronc riding, but she also competed in relay racing, flat racing, roping, and trick riding. She disappeared riding horseback into a blizzard at Green Mountain, Wyoming, in 1933. Her body was found by firefighters seven years later, identified by a trophy buckle she always wore. (Herzstein Memorial Museum.)

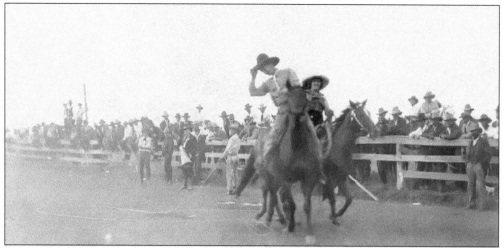

Tad Lucas, on the right, is shown here performing a roping trick at a rodeo at Clayton, New Mexico, in the 1920s. In her will, Lucas established the Tad Lucas Memorial Award, which honors women who excel in any field related to Western heritage. (Herzstein Memorial Museum.)

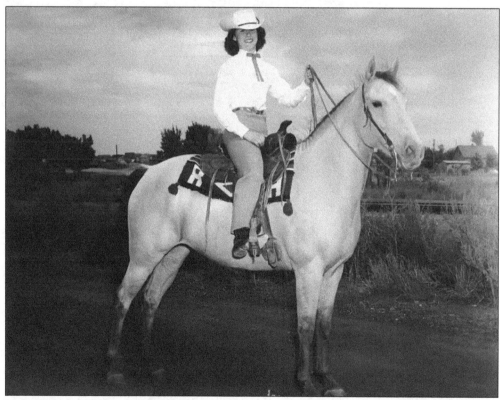

In 1982, Ruby Gobble (1930–2013) was inducted into the National Cowgirl Hall of Fame. As foreman of the Chase Ranch, in addition to working cattle, Ruby operated heavy equipment, welded gates and farm implements, and acted as veterinarian. She was also an accomplished guitar player. (Philmont Scout Ranch.)

Pictured here is Linda Mitchell Davis (1930–). Linda is the daughter of legendary rancher Albert K. Mitchell (1894–1980). She grew up on the Bell Ranch, which was managed by her father from 1933 until 1948. Linda was instrumental in the establishment of the New Mexico Farm and Ranch Heritage Museum in Las Cruces. In 1995, she was inducted into the Cowgirl Hall of Fame. (Author's collection.)

Samuel J. Garrett (1892–1989), shown here at a rodeo in Clayton, was a rodeo cowboy who specialized in trick roping. He began his rodeo career at age 14 with the 101 Ranch Wild West Show. He also appeared with Buffalo Bill Cody's and Pawnee Bill's Wild West Shows. Sam Garrett and Will Rogers taught each other rope tricks. (New Mexico State University Library, Archives and Special Collections.)

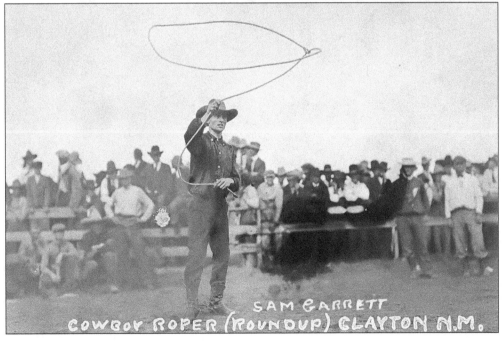

SAM GARRETT COWBOY ROPER (ROUNDUP) CLAYTON N.M.

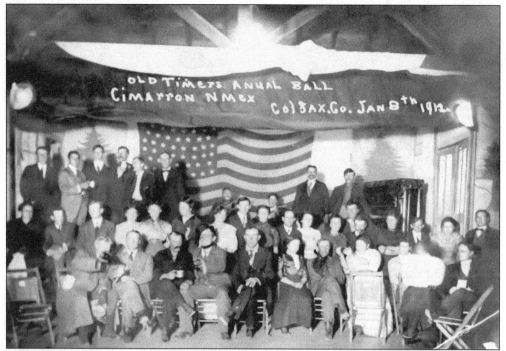

Just about any event could be an occasion for a social gathering, and many became annual events. This group has gathered for the annual Old Timers Ball in Cimarron, New Mexico. This was an especially joyous gathering, since it was being held just two days after New Mexico became the 47th state in the Union. (New Mexico State University Library, Archives and Special Collections.)

County fairs were another chance for folks from towns, homesteads, and ranches to get together. Rodeos, horse races, and livestock judging events were usually a part of the fair activities. This photograph was taken at the Union County Fair in Clayton in 1921. (Herzstein Memorial Museum.)

In addition to having an interesting subject, a photograph can present a lot of questions. Are these men (and a boy), photographed in Clayton, New Mexico around 1890, aiming at the tin can in the foreground or at the seated man's peg leg? One also wonders whether he lost the leg during a similar entertainment. (Herzstein Memorial Museum.)

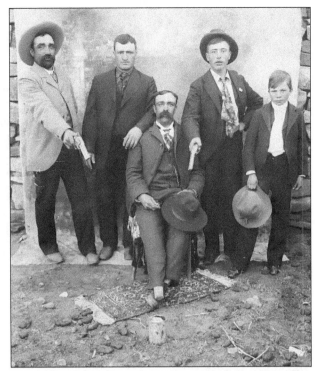

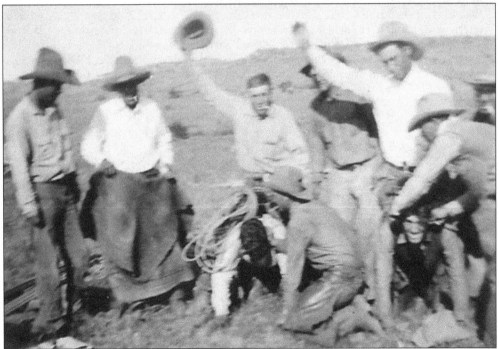

These Bell Ranch cowboys have probably staged this rodeo "event" just for the camera. S.A. Morton took the photograph at the Bell Ranch around 1930, and it is unlikely these ranch hands would indulge in such "horseplay" without such a witness. (New Mexico Farm and Ranch Heritage Museum.)

Western swing bands were popular entertainment in northeastern New Mexico in the 1930s and 1940s. Billed as "the Biggest Little Band in These Parts," the Original Trail Blazers was a popular group in Clayton, New Mexico. Bob Wills, famous band leader of the Texas Playboys, was the town barber in Roy, New Mexico, for several years. (Herzstein Memorial Museum.)

Often, entertainment in remote northeastern New Mexico was where a person found it. Someone brought an eight-year-old, 630-pound cinnamon bear to downtown Clayton, New Mexico, and led it up a tree. Not surprisingly, the bear drew a good-sized crowd. This photograph was taken around 1910. (Herzstein Memorial Museum.)

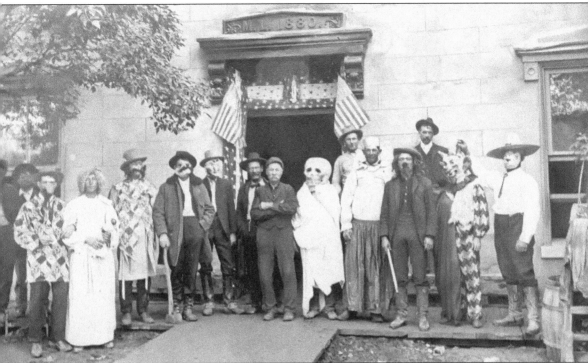

Henri Lambert (1838–1913), at center with his arms crossed in this photograph taken in front of the north facade of the St. James Hotel in Cimarron, was the White House chef when Abraham Lincoln was president. Lambert built the St. James, which was the social center for Cimarron and surrounding ranches. Costume parties were very popular. This gathering of Lambert's friends and acquaintances was photographed around 1905, during a Fourth of July celebration. Lambert's St. James Hotel had more than 40 guest rooms and was the site of at least 26 murders. The hotel is owned today by Robert Funk, owner of the UU Bar Ranch, and has recently been renovated. (New Mexico State University Library, Archives and Special Collections.)

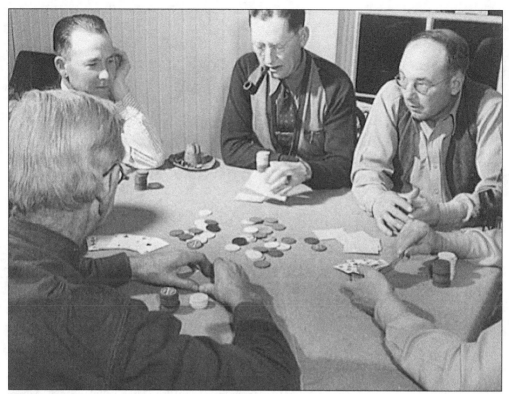

Card games were popular with cowboys and ranchmen alike. The most popular games were draw poker and five card stud. This game took place at George Mutz's ranch in 1943. (Library of Congress.)

Domestic animals were common on the ranches of northeastern New Mexico, but the understanding was usually "if they don't work, they don't eat." This cat, being petted by George Mutz's son Robert, probably earned its keep by being a good mouser. The photograph was taken by John Collier of the FSA in 1943, at the Mutz Ranch in Colfax County. (Library of Congress.)

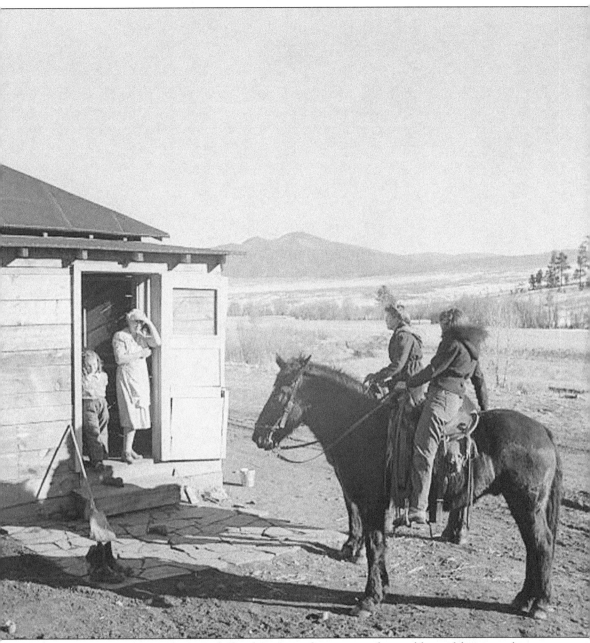

Sometimes, entertainment consisted of nothing more than visiting the neighbors, if they were close enough and chores were done. George Mutz's daughters are shown here visiting a neighboring ranch in the Moreno Valley, Colfax County, in 1943. The photograph was taken by FSA photographer John Collier. (Library of Congress.)

Visit us at
arcadiapublishing.com

CPSIA information can be obtained
at www.ICGtesting.com
Printed in the USA
LVHW060049170720
660926LV00023B/412